how to
take great vacation
photographs

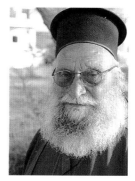

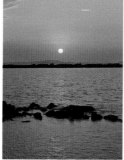
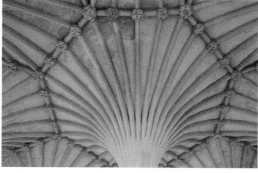

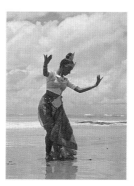

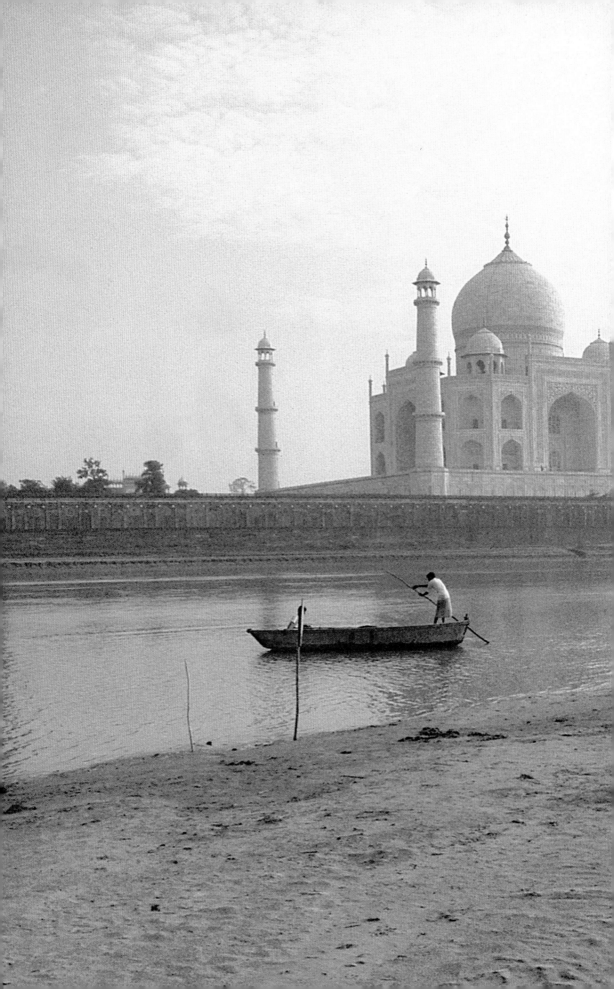

how to
take great vacation photographs

John Hedgecoe

COLLINS & BROWN

First published in Great Britain in 2003 by
Collins & Brown Limited
64 Brewery Road
London N7 9NT

A member of Chrysalis Books plc

Distributed in the United States and Canada by
Sterling Publishing Co.
387 Park Avenue South
New York NY 10016

The right of John Hedgecoe to be identified as the
author of this work has been asserted by him in
accordance with the Copyright, Designs and Patents
Act, 1988.

9 8 7 6 5 4 3 2 1

British Library Cataloguing-in-Publication Data:
A catalogue record for this book is available from
the British Library

ISBN: 1-84340-057-X

Editorial Director: Roger Bristow
Contributing editor: Chris George
Project managed by Emma Baxter
Design manager: Liz Wiffen
Designed by Anthony Cohen and Paul Wood

Reproduction by Classicscan PTE Ltd, Singapore
Printed and bound by Imago, Singapore

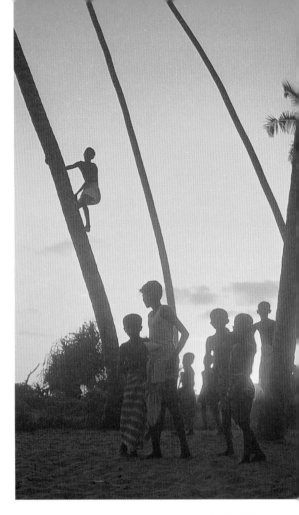

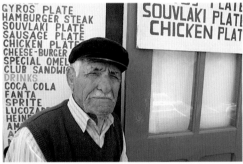

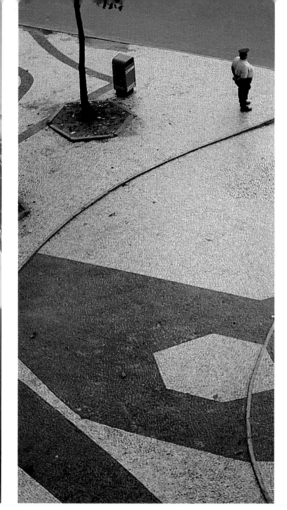

Contents

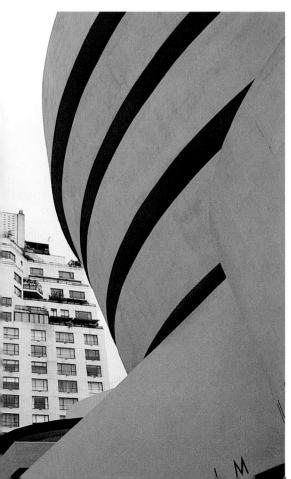

Chapter 1
Packing
your bags

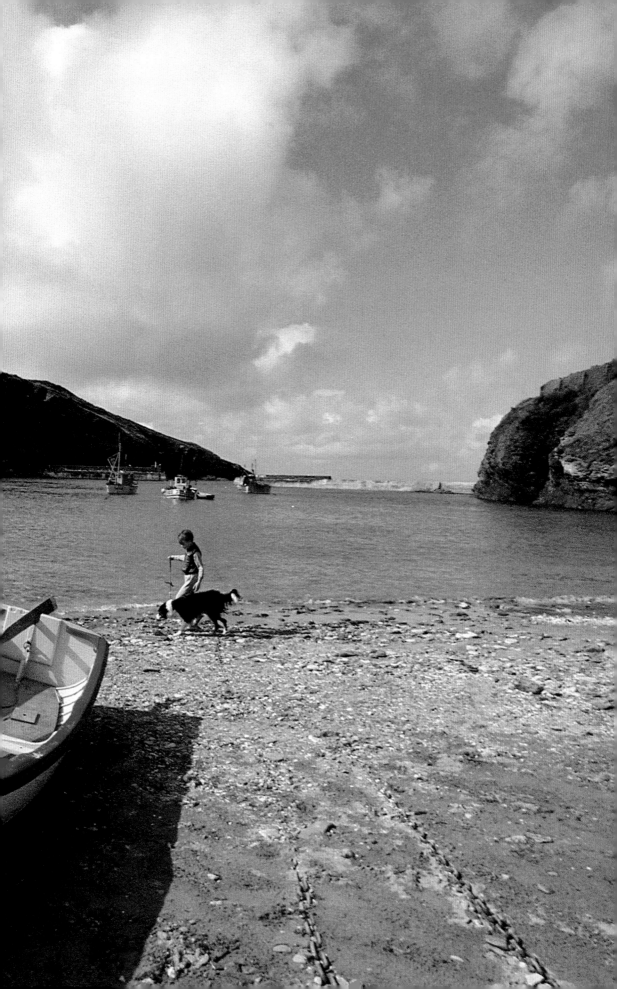

Choosing a camera

Buying a camera means making a number of decisions. Do you want convenience, or do you want full creative control? What range of subjects do you want to shoot? And do you choose traditional film, or take the digital route?

THERE ARE HUNDREDS and hundreds of different cameras on the market, and choosing the right one for your holiday photography can seem like a nightmare ordeal. But essentially there are two different types of camera which are both widely available and suitable for travelling. The first decision that you have to make is which of these two suits your purposes and aspirations best.

First there is the compact, or point-and-shoot, camera which is designed to be small and easy to use. Then there is the SLR (single lens reflex), which is bulkier, has more controls, and usually offers changeable lenses.

Over the years, the differences between these two types of camera have become slightly less distinct. Compacts now often have useful built-in zooms, and can offer some degree of control over flash and exposure. SLRs are much easier to use, often coming with automatic focusing, motorised film winding and fully-automated exposure.

However, despite the similarities it is important to realise the advantages of the reflex camera. As you can buy different lenses for an SLR, you can cover practically every

Compact	vs.	SLR
Simplicity Few buttons to worry about – you just point and shoot		**Interchangeability** Choose the lens or zoom for the subjects you want to shoot
Convenience Some models can fit in your pocket		**Freeze** Full shutter speed control for crisp action shots or for creative blur
Limited control Can buy with a reasonable zoom – but there is little creative control over shutter speeds, depth of field or focus		**Sharpness control** See and control exactly what is in focus, so unwanted detail is blurred

photographic subject. A compact's fixed lens cannot focus close enough for the smallest subjects, and cannot zoom near enough for close-ups of safari wildlife or distant sportsmen. The compact's lens cannot squeeze the interior of a room into a single frame. The SLR gives you the flexibility to do all these things, whether now or in the future.

Furthermore, a typical compact gives no

Freezing movement

An SLR allows you to pick a fast enough shutter speed to ensure that moving subjects are caught sharply in the frame. Good autofocus models adjust the focus quickly enough to keep up with the action, so you can concentrate on framing and firing.

Close focusing

Compact cameras are not good at dealing with miniature subjects, as the viewfinder gives an inaccurate view of what is being shot. An SLR gives an exact view of what the lens sees – as well as showing exactly which part of the frame is in focus.

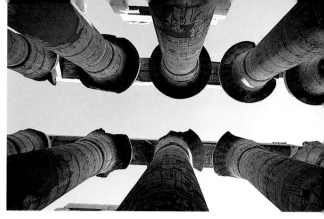

Fitting it into the frame

Most compact cameras offer a wide-angle zoom setting of 35mm or 28mm. However, for some panoramic landscapes and many architectural shots, a wider view is needed. This shot was taken with an 18mm lens on a single lens reflex camera.

Zooming into the distance

SLRs offer a far greater range of zooms and lenses than compacts – and you can change them to suit the subject you are shooting at the time. This shot of Egypt was taken with the extreme telephoto end of a 75–300mm zoom. Long lenses are essential for many types of wildlife and sports photography.

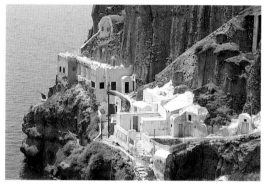

Zoom ranges on compacts

The zooms on compact cameras continue to get longer. Some can now provide you with a telephoto setting of 200mm or more – which is better for ensuring many photographic subjects fill the frame.

direct control over shutter speed or aperture. It is these two controls that are at the heart of all creative photography. With these two adjustments you can decide exactly how sharp something appears in your viewfinder – giving you the option to deliberately blur things, whilst keeping others critically focused, so as to concentrate the viewer's attention on what you want them to see. ☛

 ### Pros and cons of digital

See what you shoot
LCD display means you can see your pictures immediately

Speed of operation
Many digital cameras are slower to use than film equivalents

Low running costs
Memory is reusable. Shoot until you get the picture you want

Power hungry
Batteries run out fast. Rechargeable cells are almost essential

Choice
Models are available to suit all budgets and creative demands

PC dependency
You need a computer to make the most of a digital camera

Aperture control

On an SLR you have the choice to leave the exposure entirely to the camera, or to take various degrees of control. By deciding the size of the aperture used for the exposure, for instance, you can ensure as much of the scene as possible is sharp.

Choosing a camera continued

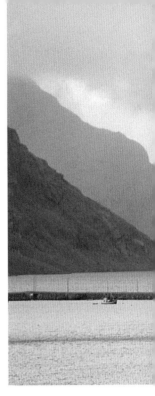

Most SLRs will set both aperture and shutter speed for you when you want to concentrate on the composition – but when required, you can take the creative reins. Good pictures are possible with a compact, but as you have so little control results are not predictable – and can often be disappointing.

Once you have decided between compact and SLR, you can then decide between film or digital. Both SLRs and compacts can be bought that record pictures onto smartcards or disks. The advantage of the digital route is the immediacy of the results. You don't have to wait, or pay, for processing, as you can see the shots using the built in display screen. This means you can share your pictures with travelling companions and confirm that you have the results that you want before moving on (important if you have travelled a long way and are unlikely to return).

Digital cameras with inter-changeable lenses can be expensive, but hybrid designs that feature large-range zooms, SLR styling and full creative control can be bought at a more reasonable price. A key consideration

Panoramic view

Panoramic cameras are often used by specialist photographers. However, for the occasional picture it is more economical to shoot the picture with your usual camera – and then to crop it at the printing or mounting stage. Those with APS cameras can choose panoramic prints at the time of shooting – knowing that the shot can always be printed full-frame at a later date.

with digital cameras is the resolution of the imaging chip. The more pixels that the CCD or CMOS chip has, the better quality the images. If you want to print your pictures, go for the model with the most pixels you can afford. A model with three million pixels is adequate for printing out A4 or US Letter-sized prints. But if you want pictures only for email or web use, a pixel count of 500,000 pixels will be more than sufficient.

 Underwater cameras

Sea life

An underwater camera is not only a fun companion on a beach holiday or when visiting an aqua park. It is also the only sensible way to record the things that you see when snorkelling. If scuba diving, it should be noted that light doesn't travel far underwater, and therefore flash is often essential and you are limited to shooting subjects that are right in front of you.

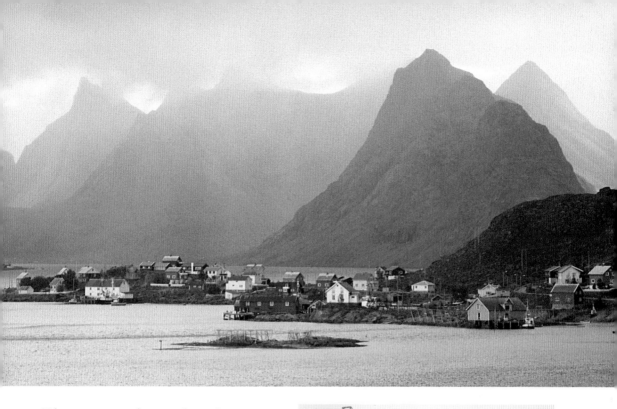

Film users can, of course, have their picture digitised later – and their main choice is between the 35mm or APS film format.

The APS format is widely used on compacts, and provides a choice of picture formats (see box), disaster-free film loading, and smaller cameras than 35mm. APS SLRs are a relative rarity – and you get a far better choice in terms of models and purpose-built lenses if you choose the 35mm film format.

Peace of mind
Waterproof cameras are ideal for many holiday situations, as the electronics of normal cameras are instantly ruined by being dropped in the sea.

Protection factors
There are two types of water-protected camera. Showerproof or weatherproof models can cope with heavy rain and sea spray. Waterproof models can be totally submerged without leaking, but some can be taken much deeper than others.

Fun for all
Models can be bought to suit every budget. For occasional use, the lowest-cost solution is a disposable camera which is preloaded with film.

Serious diving
Underwater cameras use a compact design, as it is hard to see through a viewfinder under the sea. The Nikonos uniquely offers interchangeable lenses. Underwater housings can be bought for ordinary compacts, digital cameras and SLRs.

Panoramic cameras

Why
Panoramic cameras offer long, thin pictures, whose dimensions are ideally suited to a wide range of subject, in addition to the obvious panoramic shots of landscapes and cities. They work well for many architectural subjects, and can be used upright for shots of tall towers, church spires, pagodas and so on.

APS – a three-way choice
Nearly all cameras that use the APS film format offer you the choice of taking panoramic cameras as standard. With each shot, you can select one of three formats: conventional (C) which offers the same 3:2 image ratio offered by 35mm-film cameras; widescreen (H) which provides the same image ratio as a modern TV; the panoramic mode (P) offers pictures that are three times as long as they are wide. Unlike with other panoramic cameras, the full film area is always exposed – so that you can change your mind and have a more conventionally proportioned print made at a later date.

Panoramic modes on 35mm cameras
Some 35mm cameras allow you to switch to a panoramic mode for each shot, or for a whole roll of film. However, all that happens is that half of the negative (or slide) is physically masked. You would be better off, in most cases, cropping the picture at a later stage.

Specialist service
Several cameras are specially designed to take panoramas, and little else. Using 35mm or 120 roll film, they provide a much wider than usual image area.

Aperture control

Aperture is not just one of the ways of controlling how much light reaches the film or image sensor – it also dictates how much of the picture is in sharp focus

THERE ARE TWO MAIN FACTORS that are used to control how much light reaches the inside of the camera. Shutter speed and lens aperture are used to compensate for the varying brightness of the subjects that we photograph. In darker conditions exposure can be increased, therefore, by opening up the aperture or lengthening the amount of time the shutter is open (or both).

But as well as controlling exposure, shutter speed and aperture are the fundamental ways in which a photographer controls the appearance of a picture.

The real importance of the aperture is to control which parts of a picture are in focus, and which are not. A lens can focus precisely only on a single plane at a time, but there are always points in front and behind that appear acceptably sharp. The extent of this zone of focus is known as depth of field.

Depth of field is greatly affected by the aperture that is used. Use the smallest aperture on a lens (the one with the highest f/number – typically f/16 or f/22), and everything from a few feet in front of you to the distant horizon could be in focus. Use the largest aperture (say f/4), and depth of

Background blur

A large aperture was essential for this shot of a reptile. With restricted depth of field the background is completely out of focus, concealing all evidence of the zoo enclosure . I used a telephoto lens setting of about 100mm with an aperture of f/3.5.

Close-up problems

The nearer you are to the subject, the less depth of field you have. When shooting close-ups of flowers, butter-flies and insects, use the smallest aperture possible, to keep as much as possible of the subject in sharp focus. For the picture above I used f/16.

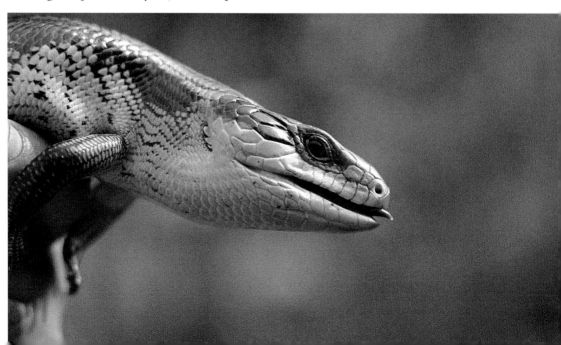

From here to infinity

With landscapes you often want to ensure everything in the vista, from the immediate foreground to the distant horizon, is perfectly sharp. Even with a wide-angle lens a small aperture is essential.

field may extend only a few feet. Deliberately restricting depth of field can be an extremely useful way of blurring a distracting background or foreground (or both) – and concentrating the focus of the picture on your chosen subject.

Depth of field is not dependent on aperture alone, though. The focal length of the lens used, and the distance the lens is focused, at also play a part. The wider the lens used, and the further away the point you have focused on, the more depth of field is increased. Depth of field, therefore is most restricted when using a telephoto lens at close range with a large aperture.

Choosing the right film speed

ISO 25–64
Very slow, very fine-grain film suitable only for the sunniest climates, in the studio, or when slow shutter speeds and tripods can be used

ISO 100–200
All-rounder for use in good light or with flash

ISO 400
For use on dull days, or when fast shutter speeds essential (with long lenses or for action)

ISO 1000–3200
Grainiest film for handheld, lowlight pictures.

Disguising the foreground

Large apertures are not useful just for blurring backgrounds. Here a long lens used with the aperture fully open ensures that the foliage is not only out of focus, but is turned into an abstract wash.

Selecting the speed

A fast enough shutter speed is essential to avoid a picture becoming blurred through camera shake, or because the subject itself was moving during exposure

As well as helping to control overall exposure, shutter speed has an important role in portraying movement within a picture.

The first thing that shutter speed can eliminate is the movement of the camera itself. However steadily you try to hold the camera with your hands (see box), involuntary movements from your muscles mean that it is impossible to keep the image in the viewfinder completely still.

As a general rule, no camera set-up can be handheld without the risk of a blurred picture unless a shutter speed of faster than 1/30sec is used. But the problem with camera shake becomes more acute the longer the lens that you use – or the more you zoom into the subject. At higher magnifications, the slight movement of your body becomes more noticeable. The simple rule therefore is always to use the shutter speed that is the reciprocal of the focal length that you are using (or faster). For a 28mm lens setting you should use 1/30sec (the closest available speed to 1/28sec). For a 100mm you would use a 1/125sec, for a 200mm 1/250sec, and for a 300mm lens setting a minimum of 1/500sec.

Slower shutter speeds can be used without the risk of camera shake, of course, if the camera is supported. A tripod should allow you the greatest range of shutter speeds – but

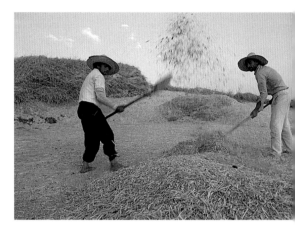

Blur is not always a bad thing

Movement in pictures does not always need to be crisply frozen. The wind and a shutter speed of 1/15sec have meant that the wheat and chaff appear blurred in this shot. This not only helps explain the winnowing process; it makes a more dramatic picture.

Keeping up to speed

The exact speed needed to freeze moving subjects is not always easy to judge – so if sharpness is essential use the fastest shutter speed possible. Here a setting of 1/500sec was more than satisfactory.

Holding the camera properly

Grip the side of the camera with the right hand firmly, but not too tightly. Use the palm of the left hand to support the weight of the lens. Stand with your feet slightly apart, keeping your elbows tucked in. Whilst briefly holding your breath, gently squeeze the shutter.

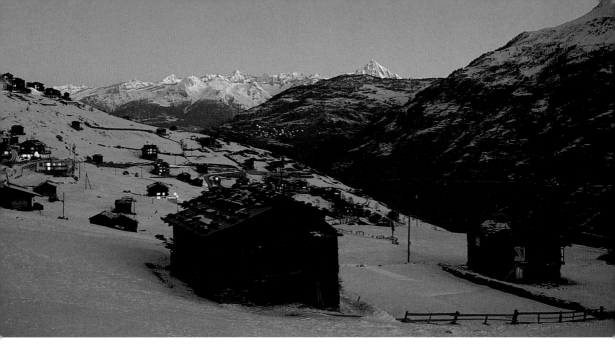

slower speeds can be used by balancing the camera on a solid surface (such as a wall or car roof), or wedging your body tightly into a doorway. Some digital cameras and SLR lenses have image stabilisation systems that help reduce the effect of camera shake.

The movement of the subject itself should also be considered, as a faster than usual speed will generally be needed to capture the action crisply on film. The exact shutter speed needed will depend not only on the speed of the subject, but its distance from the camera, the focal length of the lens, and its direction of movement. The bigger the subject is in the frame, the more marked its movement will appear. Similarly, you will need a faster shutter speed if the subject is moving across the frame than if it is moving towards the camera.

Take it slowly after dark

When the light is low, there may be no alternative to using a much slower shutter speed than you could possibly use with a handheld camera. If a tripod is not available, you can stand a camera on a flat surface, such as the window ledge, and fire the camera using its self-timer to minimise vibration. Here a shutter speed of several seconds worked to my advantage – turning car headlamps in an Alpine ski village into picturesque streaks of light.

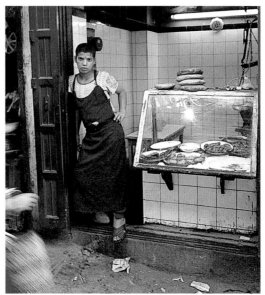

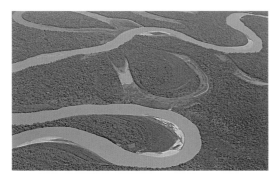

Moving platform

When shooting from a moving car or plane, you need to increase shutter speed to allow for the vibrations of the engine. This aerial shot showing the snaking path and ox bow lakes of the Amazon river was shot with a 35mm lens and a 1/250sec shutter speed.

Using blur to hide elements

Just as depth of field can hide background and foreground detail, so can slow shutter speeds. Here the passer-by in the corner is blurred, so does not detract from the main subject; but the movement provided by a 1/15sec setting suggests a busy street.

Wide lenses

Even the simplest of compact cameras comes with a built-in wide-angle lens. But the view this range of focal lengths provides is essential for the tourist

Since zoom lenses have become the norm for both SLR and compact users, most photographers now have instant access to both telephoto and wide-angle lens settings. But the exact range of focal lengths available varies significantly from zoom to zoom.

For those using 35mm film, a wide-angle lens is one which has a focal length of 35mm or less. A wide-angle lens on APS and digital cameras, which have a smaller image, will have a shorter focal length – but most manufacturers will refer to its equivalent 35mm-format length for simple comparison.

For many travel destinations, a wide-angle is the most obvious focal length to use. It gives a wide view that is ideal for panoramic landscapes, and for shooting the exteriors and interiors of buildings. It is the essential choice when you want to show everything in front of you – particularly when obstructions stop you from moving

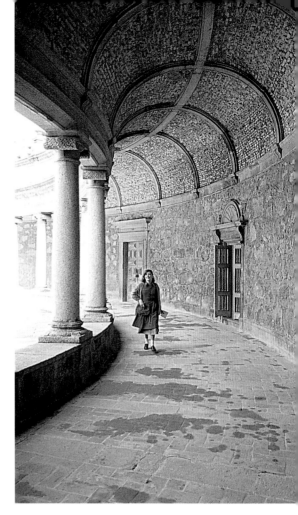

Foreground emphasis

One of the problems of a wide-angle lens is that it can give undue emphasis to the foreground. This often means that you deliberately have to arrange the composition so that this space is not 'empty'. Here a 24mm shot has given emphasis to the worn paving stones of the cloisters in the Vatican, Italy.

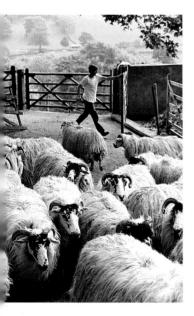

At work or play

A wide-angle is not the obvious choice of lens for a portrait. However, the broad angle of view can be extremely useful if you want to show the room that the person is sitting in – or give an indication of the work that they do. A 28mm lens shows more about the way of life of a sheep farmer in Cumbria, England, than any close-up of his face could possibly do.

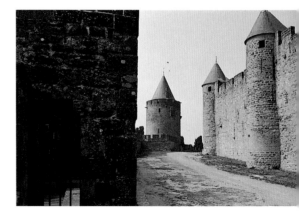

A feeling of depth

Wide-angle lenses can be used to make elements within a picture appear spaced further apart than they are in reality. Here a 20mm lens helps add depth to a shot of the mediaeval city of Carcassonne, France.

A helping hand in tight corners

Typically when photographing buildings you are restricted in how far you can go so as to fit everything in. Walls, roads or other buildings get in the way of using a more distant viewpoint – so the only alternative is to use a wider lens setting. This shot of San Marco cathedral in Venice was shot with a 28mm lens – which could be called the all-round choice for architecture.

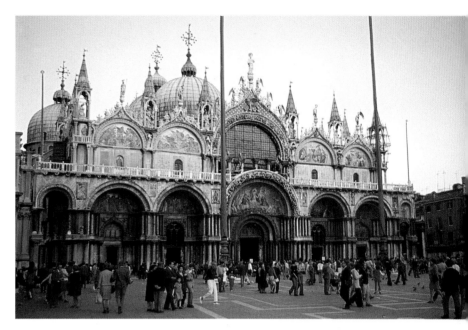

any further away from the subject.

Wide-angle lenses can also be useful for pictures of people – when you want to show the environment in which they work as well as their appearance.

A typical all-purpose SLR zoom will have a wide-angle setting or 28mm or 35mm. If you want something wider you will need a specialist wideangle zoom (such as a 17-35mm) or to opt for a fixed focal length lens, such as a 24mm. Wide-angle converters can also be bought to extend the range of the built-in lenses on some digital cameras.

Getting in close

Different lenses have different minimum working distances, which may restrict their use for close-ups or in confined spaces. Here, using a 24mm, a mirror was used to give a double view of the mural, and the resulting shot was turned on its side for effect.

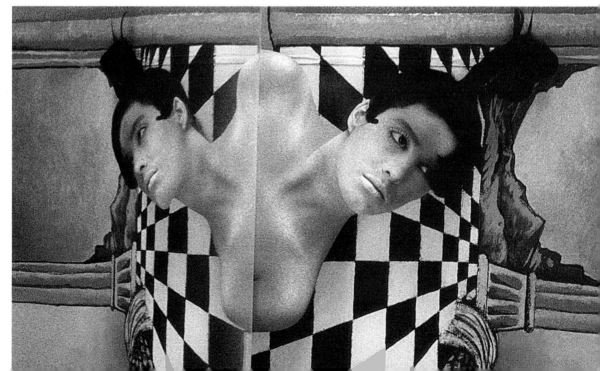

Standard lenses

Positioned between the wide-angle and telephoto settings of your zoom, the standard lens settings provide the most natural view of the world around us

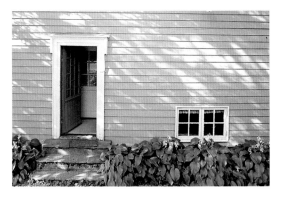

Shooting at maximum aperture
For this shot of a New England home, depth of field was not important as everything was the same distance from the lens. Using the maximum aperture of a 50mm lens, I was able to use a finer-grained film than the light level would otherwise have allowed.

IF TELEPHOTO LENSES start at around 70mm, and wide-angle ones are 35mm, then standard lens settings are the ones in between. With such a short range of focal lengths, they might not even seem worth worrying about. But it is the angle of view that this part of the zoom provides that most closely resembles that of the central vision of our own eyes.

For this reason, standard lens settings will provide the most natural view of many subjects. Most significantly, this angle of view ensures that tricks of perspective and optical distortions do not fool the viewer. A wide-angle can tend to stretch elements within a scene, whilst a telephoto squeezes them together – playing tricks with perspective. A wide-angle, moreover, can distort the shape of subjects when they are close to the lens.

A standard 50mm lens used to be the first lens that an SLR owner possessed. But even though zooms are the natural all-

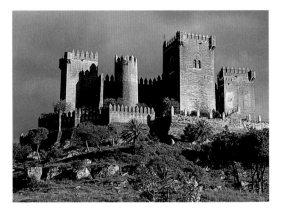

Cropping in tight
Often the focal length you use will just depend on how close you want to crop the view in front of you. The mid setting of a 35–70mm zoom fills the frame with this Spanish castle (above).

Light as a feather
The 50mm fixed focal length is usually the lightest lens in a manufacturer's range, so it is easy to find a space for it when packing for a trip. The shot below was taken in Iceland.

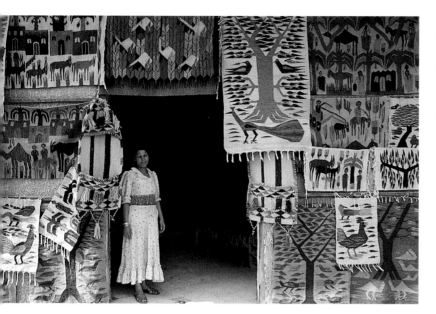

People and their surroundings

Like the wide-angle, a standard lens can be used for portraits where you want to show the person's surroundings But the 50mm is only practical if you have enough space to work in – as I did in this shot of an Egyptian carpet shop.

round choice, there are good reasons why the 50mm should be considered for a later, supplementary purchase. The reason is not the focal length, but the wide maximum aperture. For the 50mm standard lens this is typically f/2 or wider. This means that it will let in as much as four times more light than the typical f/4 maximum aperture of a mid-range zoom. This is particularly useful in low light, as it will mean that you will be able to use a shutter speed of 1/60sec, say, where otherwise you would have to use 1/15sec.

The wide aperture also gives you great scope for restricting depth of field. Wide-aperture lenses are available in a number of fixed focal lengths (and some zooms), but the 50mm is the one with the widest aperture and is the most affordable (and is also widely available secondhand).

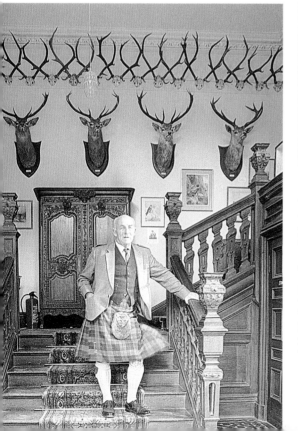

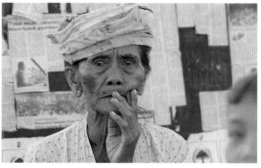

Faces that fill the frame

You can get away with using a 50mm standard lens for close-up, head-and-shoulder portraits. It gives you a natural view of the subject – without the distortion of features that a wide-angle would add.

The perfect indoor companion

It is with interior shots, in a church or museum, say, that packing a 50mm standard lens pays dividends. The maximum aperture allows you to take shots handheld that would be impossible with a normal zoom. This shot inside a Scottish castle (left) was taken with an exposure of 1/15sec at f/1.4.

Long lenses

Telephoto lens settings allow you to fill the frame with distant subjects. But the ideal maximum focal length to take with you will depend on your holiday plans

T HE MAIN PURPOSE OF TELEPHOTO LENS settings is that they allow you to get 'closer' to a subject without having to move your feet, magnifying the image in comparison with shorter lenses. They are essential in situations where it is impossible or unwise to move within a certain distance of the subject. But whilst the use of long telephotos with sport and wildlife subjects is usually essential, most subjects will occasionally benefit from the use of a more extensive zoom.

A short telephoto lens (with a focal length 70mm to 135mm, say) is often the best lens for close-up portraits, as it tends to flatten the features in a flattering way. Longer settings (from 200mm to 300mm) can be useful for candid shots – letting you capture shots of local people, or of family and friends, without their becoming camera conscious.

Even with subjects such as architecture and landscape, where the wide-angle is often the lens of choice, a long telephoto will not only allow the photographer to pick out details and individual elements in the scene, it will allow him or her to tackle these subjects in a refreshing way. The way in which a telephoto lens can seem to compress elements in the composition, or throw backgrounds so convincingly out of focus, can often be more beneficial than its narrow angle of view.

Bring the background to the fore
Telephoto lenses tend to compress perspective, shortening the distance between subjects at different depths within the frame. Here a 300mm lens is not essential to create a frame-filling portrait, as I could have got closer – but it has meant the mountain stream in the background becomes more noticeable.

Zooming in
It is a popular misconception that a wide-angle lens is all that is needed for landscape photography. For this shot I want to unite the Moroccan farmhouse, mules and olive tree within a single frame – and the only way to do this without the olive tree appearing too large was a focal length of around 85mm.

The exact length of lens required will depend on the subjects you find at your destination. The further away you are, and the smaller your subject, the longer the lens you will need. On a safari you will benefit from the magnification of a 400mm, whilst shooting surfers from the beach you may need an 800mm. Such extreme focal lengths are not often found on zooms, requiring you to buy a bulky additional lens (or use a teleconverter). Zooms for SLRs, however, are widely available with a maximum focal length of 300mm – capable of dealing with most subjects, including action and nature.

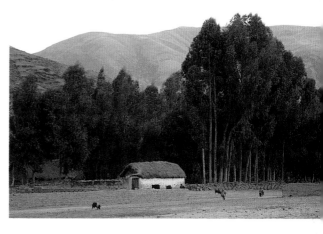

Finding the foreground

I was unable to use a wider lens for this landscape shot, as the lack of immediate foreground interest would have meant a lot of empty space in the frame. Zooming in, with a focal length setting of around 100mm, the pig becomes the foreground interest for this Moroccan mountain scene.

Avoiding undue disturbance

Even if the people you meet on your travels do not object to being photographed, a long telephoto lens will allow you take their picture without invading their personal space. This shot of a Moroccan shepherd was taken with a 200mm lens.

Bird in the bush

The focal length of lens that you need to tackle wildlife will depend not only on the creature's size, but also on how timid it is, and how dangerous it is. Although a heron is a large bird, and not particularly shy, I did not want to risk missing the picture by approaching too close. I therefore took this close-up with a 250mm lens setting.

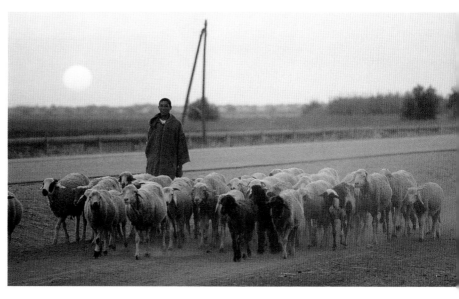

The digital era

Digital manipulation can transform your pictures in all manner of useful ways.
Whatever camera you use, your whole approach to photography may change

Whether you use a traditional film camera or a digital camera, computer manipulation of images has had a profound effect on creative photography in recent years. It has always been possible to play around with pictures after they have been taken, using darkroom and retouching techniques. But digital manipulation packages, such as Photoshop, have turned highly specialised processes into relatively straightforward ones. Effects that can take hours to achieve in a darkroom can be created in a few minutes on a computer. Furthermore, if you make a mistake, or you need another print, there is no need to start again.

Those using digital cameras have a head start, but film users can have their pictures digitised by their processing lab, or using their own scanner (see box overleaf). To begin manipulating, all that is needed is a modest, though relatively modern, computer, and a manipulation package (an excellent low-cost choice is Adobe Photoshop Elements – a budget, but only slightly stripped-down, version of its professional package).

The holiday photographer, of course, is unlikely to take a laptop to a destination, just so he or she can transform and perfect each image of an evening. Such things are more sensibly left until the return home. However, the fact that pictures can be changed at a later date can have a significant effect on the equipment that you take with you on holiday – and on the pictures that you actually take. Those who have got used to working in the digital darkroom always have half an eye on how the shot they are shooting could be improved on a PC.

It is not uncommon, for instance, for photographers to use two cameras in tandem – one with black-and-white film, and the other with colour. But in the digital domain switching from colour to black and white is a single-stage process – and now photographers are increasingly shooting everything in colour, even if they know that eventually the shot will be used in black and white.

Similarly, some accessories and specialist equipment can be adequately mimicked on the computer. Simple filter effects, such as graduated skies, can be introduced into a picture with a manipulation program – which might save on how much gear you have to cart around the globe with you. Even

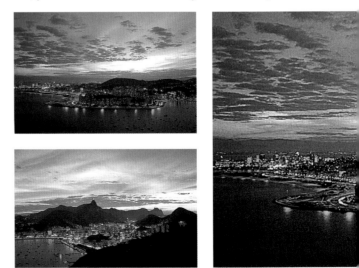

Stitching the landscape

Some photo-editing software packages contain applications that allow you to join together shots taken from the same vantage point to make a single panoramic shot. These two pictures of Rio de Janeiro, Brazil, were overlaid on a computer – and with a little manipulation the join becomes unnoticeable. The effect is much more convincing than the traditional method of sticking different prints together.

Clearing the clutter

In the original view of this mountain village, tourists, road markings and litter ruin the scene. These can be removed in a matter of minutes on a PC. More significant changes can also be made.

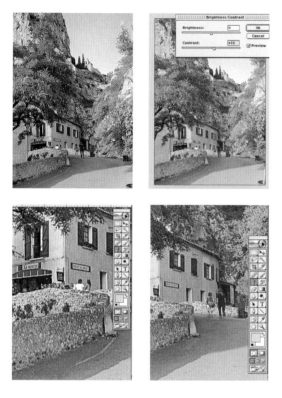

professional architectural photographers think twice about taking a bulky and valuable shift lens with them on an overseas assignment – but now converging verticals can be corrected for on screen, once you return home.

Digital manipulation can also help you to recover from photographic disasters. A scratch on the film, always best avoided, can be airbrushed out. Slight exposure problems and unfortunate colour casts can also be corrected. ☛

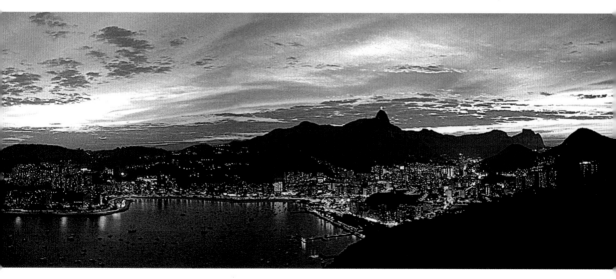

Removing scratches and stains
However hard you try to keep your negatives and slides clean and pristine, they inevitably pick up dust, dirt and scratches over time. This shot of a back-packer in the Australian outback has got severely stained and scratched. Before the arrival of digital manipulation, such a slide would be fit only for garbage. Now it can be spruced up and made to look as good as new, with a minimum of effort.

Into the digital domain

Processing laboratories
Most processing services will now digitise your pictures for you at the time of developing. This is a cheaper than paying for this service at a later time – although all your shots are digitised, rather than just having your best ones done. As well as getting your slides or prints, the digital images are returned on CD.

Flatbed scanners
The simplest way to scan your own pictures is to use a low-cost desktop scanner, but it will be suitable only for prints.

Film scanner
The best quality solution for scanning your pictures at home is to use a special film scanner. These offer much high resolutions than a normal flatbed scanner. They scan 35mm negatives and slides themselves – either in mounts or in strips. An APS film scanner is designed to take the entire film cartridge, loading the processed film automatically.

Adjustments to contrast, colour, sharpness, density, saturation and so on need not be just applied to the whole frame – they can be applied to selective areas of the picture.

One of the greatest advantages of digital manipulation, as far as the travel photographer is concerned, is its ability to lose unwanted elements in the composition. Inevitably, some of the more photogenic places that you will visit on holiday will be the ones which are swarming with tourists. However early you get there, however patient you are, and however hard you work at finding a suitable viewpoint, it is sometimes impossible to eliminate people from your shots. Even if you do succeed, signs of a tourist invasion – in the form of garbage and advertising for ice-cream – will often intrude. Such things can be surgically removed using, primarily, the software's cloning stamp. Once you are familiar with how this tool works, you

Correcting perspective

As you need to tilt the camera upwards, converging verticals are almost inevitable when using a wide-angle lens to shoot tall buildings. The pro solution is to use an expensive, heavy shift lens – but nowadays anyone with a computer can correct these shots when they get back home.

can organise the composition to ensure that this retouching process can be done as effortlessly as possible (it is more laborious to cut something from a shot if it needs to be replaced by a complex background).

This knowledge will also allow you to take pictures from angles that other photographers might avoid. A satellite dish, say, might look out of place on a picturesque mountain chalet – but once you know it can be removed it is no longer an obstacle to your taking a picture from that vantage point.

It is important that you still try and get the composition and exposure right at the time of shooting. A few seconds of attention with the camera can still save minutes in front of the computer. Manipulation is an extra tool, not a solution for sloppy craftsmanship.

Electronic postcards

E-mail is not just a great way of sending messages, it is a great way of showing your pictures to others – wherever they live in the world. Whilst on holiday, those with digital cameras could easily send their own pictures to friends and relatives – instead of buying a postcard. Cyber-cafes can be found in most cities, and many hotels offer internet facilities. Using your own e-mail account, you can then send low-resolution shots as attachments. Your picture will get there quicker than a postcard – and may well be much cheaper to send.

Using flash

A flashgun is an essential accessory for taking pictures after dark, but it can also be surprisingly useful during the hours of daylight

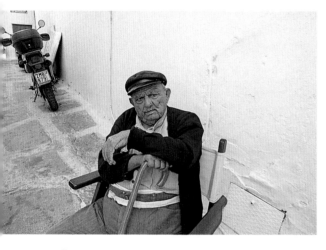

Brightening up the scene

Fill-in flash is a great way of adding punch to your pictures when shooting in indirect light – such as on a cloudy day. In a back street, this Greek gentleman is primarily lit by light reflecting off the white walls and buildings. But to ensure his face was not overshadowed by his cap I switched on the built-in flash unit on my Pentax SLR – boosting the illumination to the immediate foreground. This also intensifies the blue of his clothes.

MANY CAMERAS, including SLRs, have built-in flash units nowadays, so that the traveller may no longer have to make the decision to pack the flashgun for the journey. But for after-dark photography, these miniature tubes are rarely powerful enough or correctly situated for great results. The flash provides a harsh lighting with strong shadows – and being so close to the lens creates the additional problem of 'red-eye' (see box).

A supplementary flash-gun, on the other hand can be positioned so that the subject is lit from an angle – by mounting the unit on a bracket to the side of the camera, or by angling the head upwards so the light bounces off the ceiling or purpose-built reflector. Separate flashguns can also be fitted with devices that soften the light, for more natural-looking results.

Where built-in flashguns really prove themselves useful is during daylight. The exposure for fill-in flash is usually handled automatically – avoiding the complex calculations that were once necessary with bolt-on units.

Fill-in flash is useful in many lighting situations – but only when the subject is within a few feet from the camera, otherwise the light output is not powerful enough. In bright weather, the flash can reduce contrast, helping to avoid unsightly shadows in close-ups of people's faces. In dull weather, the flash has an almost opposite effect – increasing the contrast so that the subject in the foreground stands out from a grey background, and putting the colour back into their clothes.

As black as night

Flash used at night tends to produce unnaturally dark backgrounds, as flash power falls off quickly over distance. With some subjects this effect is acceptable – and it can be used to hide distracting backdrops. However, for a more natural-looking effect, it is sometimes necessary to combine the flash exposure with a slow shutter speed.

Avoiding black eyes

Bright sunlight is not ideal for portrait pictures – as it creates unpleasant areas of shadow in the eye sockets and under the nose of the subject. A simple way of eliminating these is to use the camera's flash to fill in the dark areas.

Bouncing the flash

A flashgun with a tiltable head allows you to improve the quality of flash lighting in dull conditions. The tube is angled upwards so that the light bounces off a neutrally coloured ceiling, or off a small white reflector that fits to the flashgun itself. The bounced light is softer and less directional, so does not cause the bright hotspots and marked shadows associated with straight, on-camera flash.

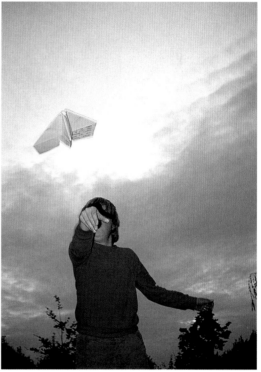

Eliminating red-eye

What is it?
Red-eye occurs when flash light reflects off the retina, illuminating the blood vessels in the eye.

Get closer
Red-eye is more marked the further away you are from the subject. Get closer, and use a wider lens setting if necessary. Or, if possible, move the flash further away from the lens.

Modern solutions
Cameras with built-in flashes have red-eye modes, where the flash strobes to reduce the size of the iris and the extent of the problem.

Killing the silhouette

Flash is also invaluable when shooting into the sun – outdoors, or when the subject is in front of a bright window. A boy playing with a paper plane becomes an anonymous shadow (right) when shot from low down against the sky. By adding flash (above) some balance is restored to the shot.

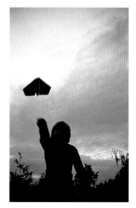

Using filters

Filters can be used for making the smallest corrections to the colour of your pictures – or to transform your shots with outlandish special effects

FOR MOST TRAVELLERS, the amount of space you can afford for accessories is small. But although filters are rarely essential, they are extremely portable, and can have a dramatic result on your pictures. Most filters are designed to fit on the end of the lens – either screwing directly into the thread of the lens itself (round filters) or slotting into an adaptor which screws onto the lens (square filters). Square filters have the advantage that they can be changed quickly, and can be used on several different-sized lenses. Some digital cameras offer a range of electronic effects, which mimic the function of a filter.

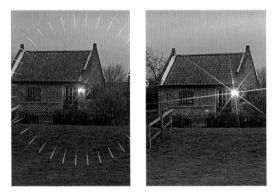 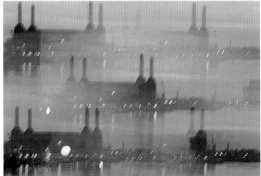

Starburst and diffractors

Starburst filters have an etched grid, which turns bright lights in a scene into stars (in the example above right, the filter creates 8-pointed stars). Diffractors (above left) perform a similar role, but add a coloured pattern. Both are useful for nightscapes.

Multi-image filters

These lens attachments create a kaleidoscopic image of the scene in front of you – multiplying the subject a number of times. Different filters provide different numbers of images (five in the above example). Of limited use, as results are repetitive.

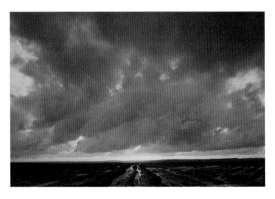 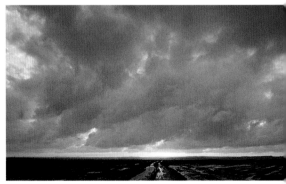

Solid colour filters

Filters with uniform, bright colours are usually reserved for use with black-and-white film, altering the relative strengths of different tones, and providing dramatic cloudscapes. But they can occasionally be used with colour scenes. Here the same skyscape has been shot with orange, yellow and blue filters.

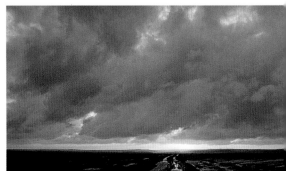

A useful all-round filter is the skylight, which cuts out some of the UV glare found in coastal or mountainous areas whilst warming the colour of the shot slightly. A fitted skylight can be left on the lens to protect the front element from dirt and damage.

Filters can be divided into three broad groups. Colour correction filters are used with slide film, and alter the overall colour balance for different lighting types. Filters for black-and-white film are strongly coloured to increase contrast or change the tonal balance. Most other filters are designed to have a pictorial effect over the image – some of the main examples of which are illustrated here.

Polarisers

A polariser is one of the most desirable filters to take away with you as it has so many uses. It can reduce reflections from glass and water. It can boost the colour of painted and shiny surfaces. It can be used to beef up the colour of the sky (without filter, left – with filter, below). You alter the effect's intensity by rotating the filter.

Soft-focus filters

Soft-focus filters are designed to give a dreamy, misty feeling to shots – helping to create romantic mood or a feeling of nostalgia. The above soft-focus filter uses a "centre-spot" design – where the effect is applied only to the peripheral areas of the picture.

Graduated filters

Graduates are particularly useful when faced with a large expanse of featureless sky – adding colour to just one half of the scene. The strength of colour and steepness of graduation increases with wider lenses and smaller apertures. Natural-looking or neutral colours, such as blue and grey, are the most useful.

Warm-up filter

Warm filters add a yellow or orange tint to a picture. This takes away the blueness of a misty day or a mountain panorama. It can also be used to give portrait subjects a stronger suntan. In this shot, a warm-up filter has been used to intensify the colour of a sunset.

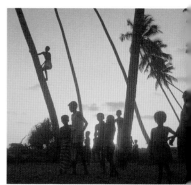

Chapter 2
Seeing
the picture

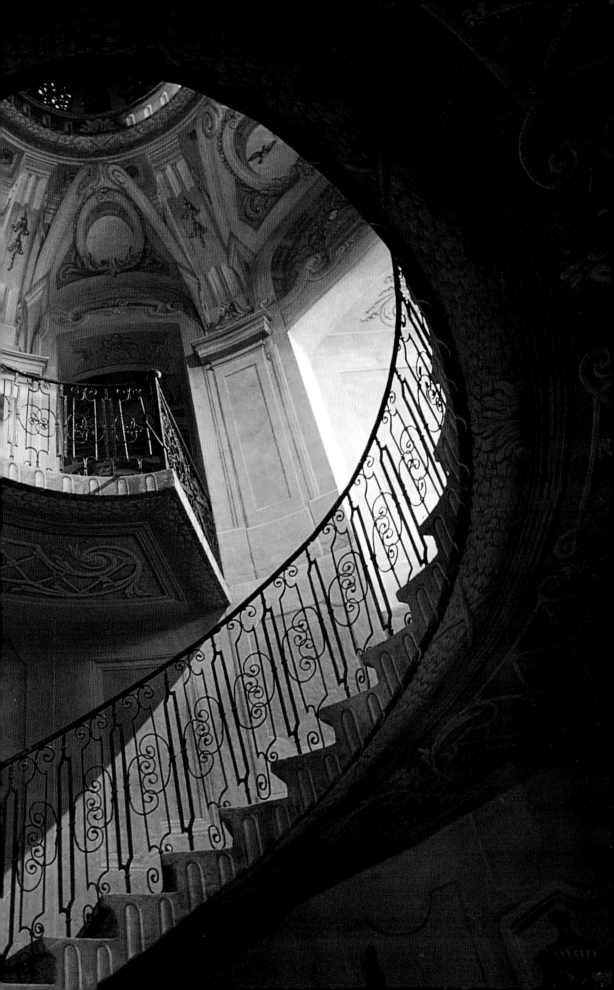

Light and day

The position of the sun is fundamental to how your pictures are going to turn out – and it's not simply a matter of waiting for the clouds to disappear

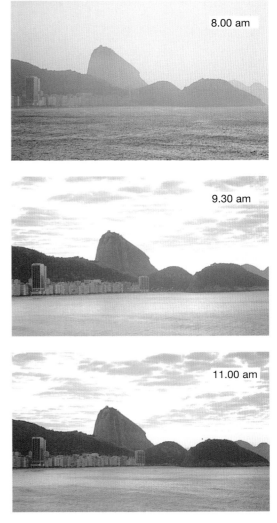

8.00 am

9.30 am

11.00 am

LIGHT IS ESSENTIAL FOR PHOTOGRAPHY – but for good pictures, it is the quality of the light, rather than the quantity, that is paramount. Outdoors it might appear that you have very little control over the lighting, as you rely so heavily on the sun. But the photographer can change the lighting in two different ways. Firstly, you can alter your camera position, so that you change the angle of the sun's rays in relationship to the subject – as this moves the shadows. Secondly, and less obviously, you alone decide when the picture is taken. If the sunlight is too intense, or muted by heavy cloud, you may have the option to take the picture later.

Choosing the time when you take pictures is not always easy when you are on holiday. However, it is important to realise that sunlight changes throughout the day. The angle of the sun changes, of course, so a subject that appears as a silhouette in the

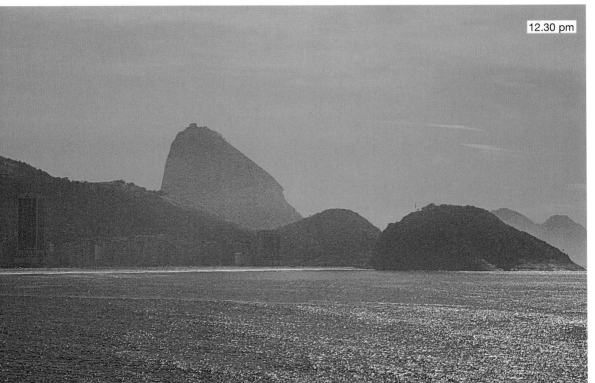

12.30 pm

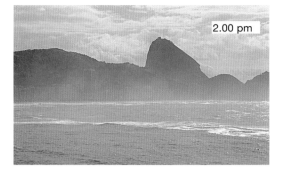

2.00 pm

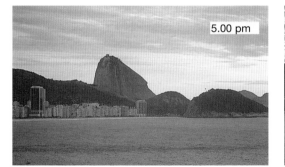

3.30 pm

morning will not be backlit in the afternoon. The actual colour of sunlight also changes throughout the day. At dawn and dusk the light might be a warm orange or yellow, if the atmospheric conditions are right. But in cloudy conditions, when the light is low, or when the subject is in the shade, your pictures may have an overall blue tinge – because the subject is at least partially lit by light that is reflecting from the sky itself (this is known as skylight).

A day in Rio

Taking a series of pictures of a panoramic scene from the same spot throughout the day can make an impressive, and informative, sequence. This one was shot from a hotel balcony in Rio de Janeiro, Brazil. Notice how the colours of the sky and the detail in the scene can change, sometimes unpredictably so, from one hour to the next.

5.00 pm

6.30 pm

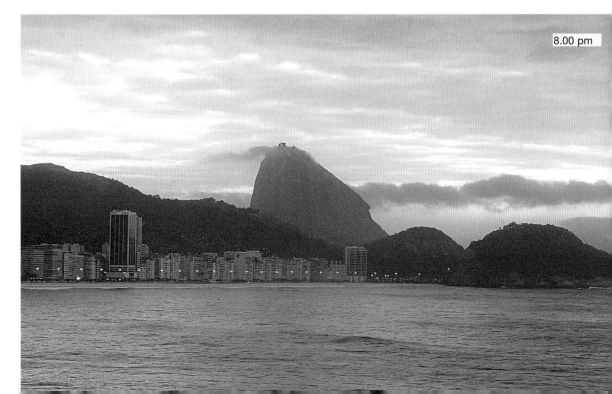

8.00 pm

The waiting game

Many holidaymakers view cloud as the enemy – but to the photographer it can be a powerful friend

THE LIGHT DOES NOT CHANGE JUST with the time of day; it can also vary from minute to minute. In many parts of the world, the sun is regularly obscured by clouds. For those working on their suntan, this may be unwelcome – but the advantage to the photographer is that it creates a different type of lighting, which can actually benefit some types of photograph.

Direct sunlight creates scenes with strong shadows – which can be useful when you want to emphasise texture, or to show colours at their brightest. But bright sunlight can also create situations where there are so many shadows that it is actually hard to work out what the subject is, let alone see the detail. Portraits, for instance, rarely work well in bright light.

Clouds, as far as the photographer is concerned, are giant diffusers – which soften the light by scattering it slightly. Shadows therefore become less distinct, and contrast in the scene is reduced.

The amount of diffusion will depend on the thickness of cloud, and by picking your moment to fire the shutter, you can get just the right degree of softness (or harshness) to suit the subject. As clouds move across the sky, they also tend to break in different places – creating gaps where the sun can shine through. The photographer can use these like spotlights, waiting for them to hit the part of the landscape they are interested in before taking the picture.

Picking the right balance

With rolling light clouds, I was able to pick the type of lighting I wanted for these shots of the Arsenale, Venice. Direct sunlight (left) makes a striking wide-angle shot, but large areas of the scene are hidden in shadow. With softer, cloud-assisted lighting (right) you get a better record shot – but no drama. Strong lighting works perfectly for the close-up (above) though, as the shadows show the three-dimensional shape without over-complicating the composition.

Ever-changing scenery

Light cloud creates a patchwork of light and dark areas over a landscape. As the cloud moves, the areas that are lit up – and highlighted within the composition – change. By waiting for the light to hit the areas of interest to you, the composition is strengthened. These three shots of a typical Norwegian scene show how much the picture can change in just a few minutes.

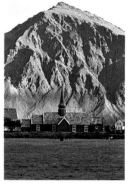

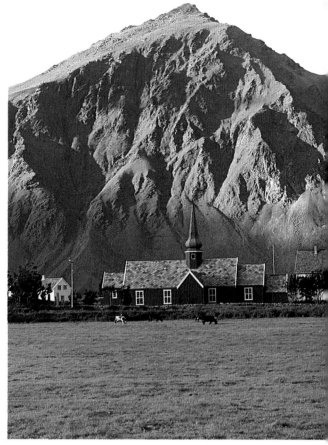

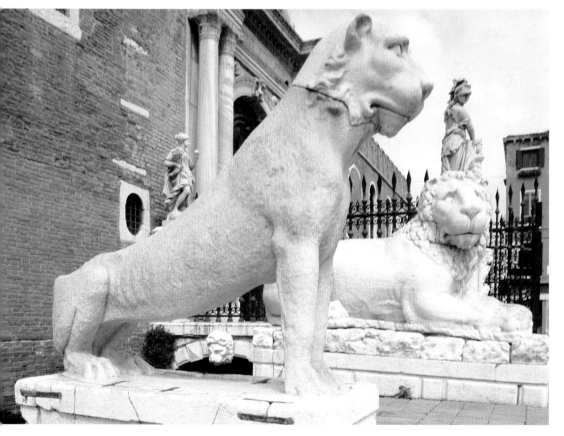

Silhouette and shape

Shooting into the sun can be used to create a simple yet powerful composition where the outline of the subject becomes the centre of attention

Photographers used to be told to stand with the sun over their shoulders. For many holiday pictures, this is still good advice. The frontal lighting ensures good colour, there is little contrast to cause exposure errors, and shadows are hidden from view. However, if you took all your pictures in this way, the shots in your holiday album would be rather predictable – so sometimes it is worth doing completely the opposite, and standing so you are actually facing the sun itself. ☞

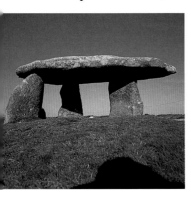

Standard view

With the sun behind you, colours show up well, and there are no problems with exposure.

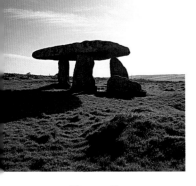

Alternative

Walking to the other side of the stones gives a different, and equally interesting view of Lanyon Quoit, Cornwall.

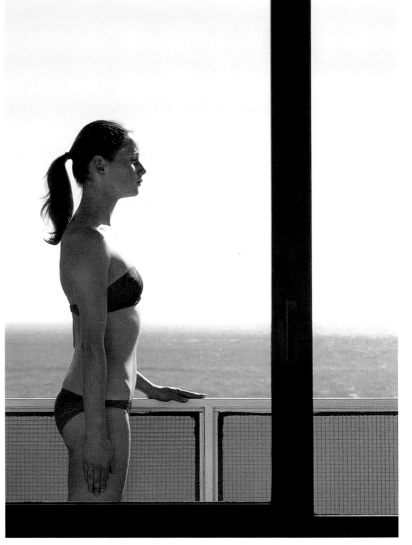

Rimlighting in Spain

With the Spanish sun out of shot, most of the subject is in silhouette – but the edge of the woman's body catches the light, creating an effect called rimlighting.

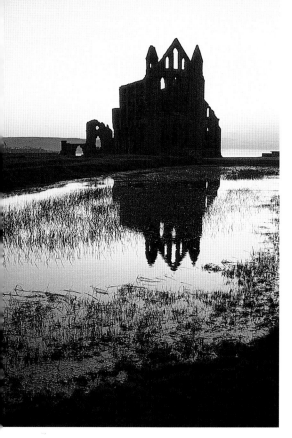

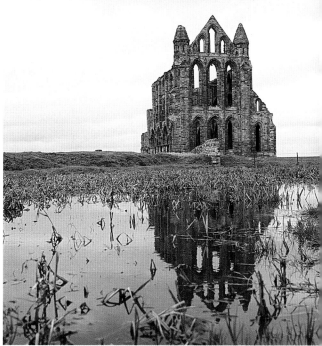

Whitby Abbey, Yorkshire

Using backlight works particularly well with some subjects, such as the ruins in the shot on the left, as it adds a sense of mystery to the shot. The approach also works in dull conditions – where a shot taken with frontal lighting (above) tends to look drab.

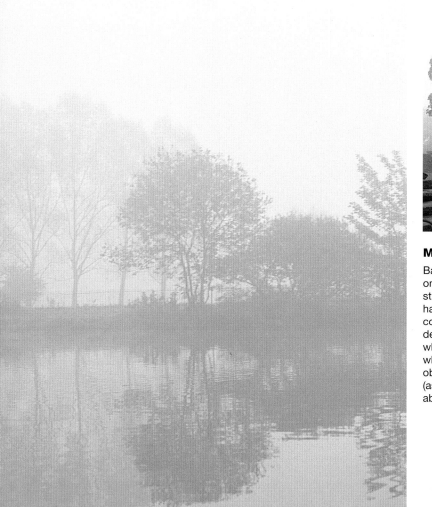

Misty mornings

Backlighting is not the only way in which to stress shape. Mist and haze not only dull colours and obscure detail, but provide a white backdrop against which the outline of objects is accentuated (as in the examples above and left).

Silhouette and shape continued

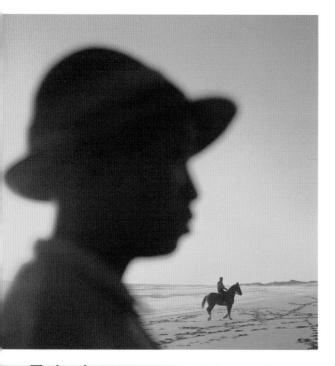

Backlight is an excellent way of showing the shape or outline of a subject, and it is often surprising how well we can recognise things from this one element alone – with colour, form, texture all being lost in shadow.

If the lighting is strong enough, the composition becomes a silhouette – particularly if you expose for the bright background rather than the subject.

Backlight doesn't always mean silhouettes, however. With less intense lighting, it is possible to set the exposure for the subject itself – as the subject is not in darkness, but lit by soft light reflected off the ground, buildings, the sky, and so on. This soft lighting can be particularly useful for portraits in strong sunlight. To avoid problems with exposure, ensure that as much of the bright background is cut from the picture as possible.

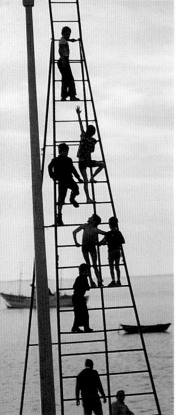

Yellow wash

As silhouetted shots are monotonal, you can get away with using the strong-coloured filters designed for use with black-and-white film. This was taken on a South African beach, with a yellow filter.

Complex composition

Even complicated shapes can sometimes work well as silhouettes. The figures on the impromptu climbing frame make a fascinating study of children at play.

Sunset silhouette

Sunsets are a naturally photogenic subject – but they look better if you can provide a focal point for the coloured backdrop. A silhouette of a figure or a tree are perfect candidates.

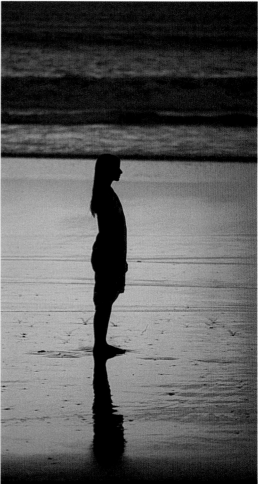

Path of light

Wet sand on a beach provides an interesting element to many seaside shots – as it reflects the colour of the sky, and provides mirror images of the people standing on it. Here the composition has been deliberately arranged so that the wet sand creates a diagonal path of light, leading your eye through to the silhouetted figure.

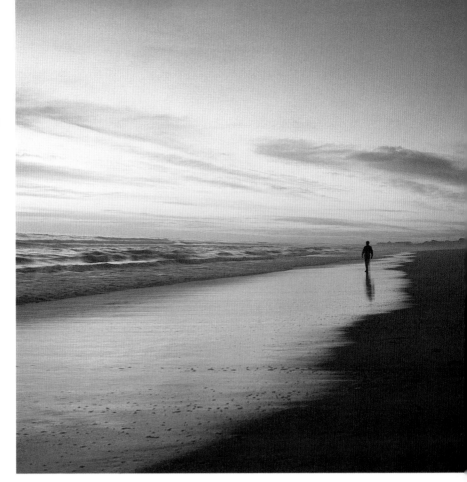

Exposure lock

To get a silhouette, you need to expose for the background, and not for the subject. The easiest way to do this on many cameras is to fill the frame with the sky alone, hold the exposure lock button, and then reframe to include the subject (as for the shot above). If the subject fills only a small part of the frame (as in the shot on the left), this indirect metering approach may well not be necessary.

Colour on a dull day

Most photographers loathe poor weather – but even on the greyest days there are still pictures to be found

Curious construction

Unusual sights make interesting pictures whatever the lighting – this railway carriage had been turned into a home. Spotted in Lincolnshire, England.

COLOUR IS THE MOST POWERFUL and emotive of all the photographic elements. It can grab our attention, and can turn a mundane subject into a winning photograph. Usually colour looks its strongest when lit with frontal lighting – but with some subjects this approach creates pictures where the colour is just too strong. Certain colours, particularly reds, yellows, oranges and pinks, can dominate a composition – drawing the eye into the picture. To do this with subtlety, you need to use indirect lighting – such as that found on an overcast day. The diffused lighting will tend to soften the brilliant hues slightly. It can also be an approach that can help to control some of the more garish colour combinations that you find on your travels – and will give you a theme to follow on those drab days of your vacation.

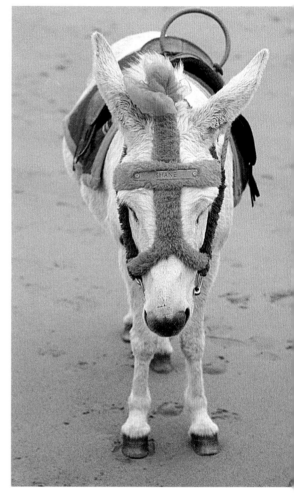

Fields of colour

The flower fields of the Netherlands create surreal blocks of bright colour across the landscape. There is so much colour, from the tulips and other bulbs, that even on an overcast day the effect can still be rather overpowering.

Seaside attraction

This colourful harness is designed to attract children to the donkey rides on Scarborough beach. The combination of hues would look garish in the sun, but here it adds much-needed colour to a grey Yorkshire afternoon.

Glow in the dark

Bright colours on an overcast day are not just successful in close-up – they also can create a focus of attention in a distant scene. This Norwegian landscape looks oppressive at first, but the mustard-yellow house sings out in the dark mountainscape.

Storm lighting

Even on the dullest days, the weather can suddenly break. Sunshine after heavy rain can be particularly attractive – as you can combine the benefits of frontal lighting with a dramatic, dark skyscape. The conditions won't last long – so you have to be ready.

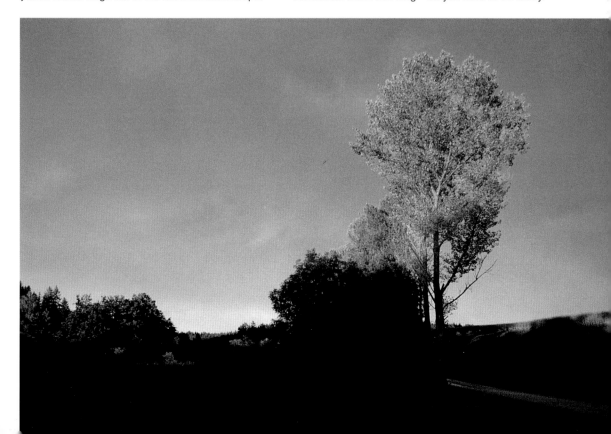

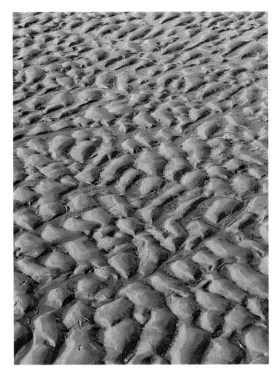

Patterns

Once you start looking, you will find patterns everywhere you go – the challenge to the photographer is to find a way to show them on film

FROM THE LEAVES ON A TREE to the bricks in a wall, we are surrounded by repeated shapes wherever we go. But because pattern is everywhere, we tend not to notice it readily. However, by choosing an unusual camera angle, a photograph can emphasise this repetition and symmetry.

Often the answer is to zoom in, or move in, close, so that the pattern fills the frame – isolating it from its surroundings.

A high or low camera angle can also be useful, as it can show things from a viewpoint that the human eye is not used to. It is also worth trying to photograph the pattern from oblique angles with wider lens settings, so that you create some variation in size amongst the identical shapes – the ones nearer the camera appearing much larger than those which are further away.

Low-level shot

Nature creates as many patterns as man. This is the textured pattern created on the beach by the outgoing tide. Tilting the camera ensures the shapes diminish in size across the frame.

Distant view

Rows of houses are frequently of equal size and shape – but you rarely see this. Here a distant view, and the parallel lines of terraces on a hill, make the symmetry obvious.

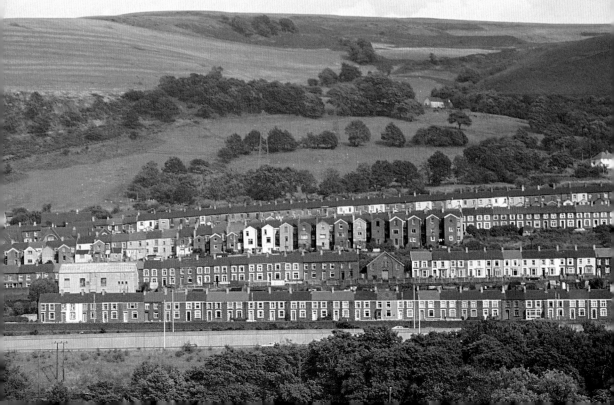

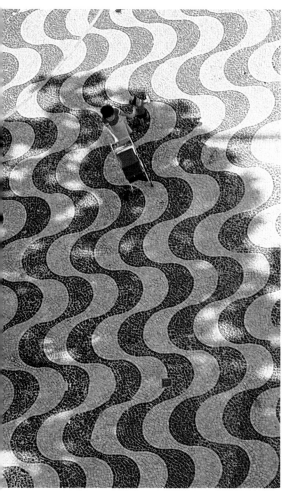

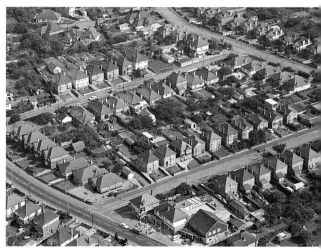

Do look down

Shot from a window, this high-angle view shows the mosaic pattern of the tiles in a way that would not be possible at ground level. The inclusion of the mother and child helps explain what you are seeing.

Window seat

The final approach to the airport can often provide you with fascinating aerial shots of your destination – where the pattern of the roads is revealed. At check-in, ask for a window seat away from the wing.

Zoom in for detail

Architecture, both old and new, uses pattern for both decoration and for structural strength. This spectacular vaulted ceiling can be found in Wells Cathedral, Somerset, England.

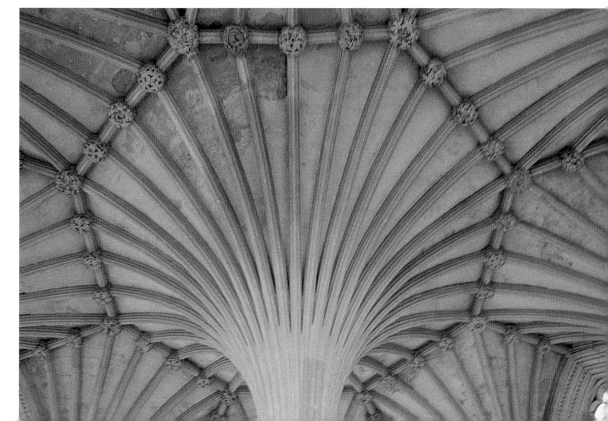

Reflections

Water not only helps create a double image of your subject – it can frequently provide you with an original view of a well-known landmark

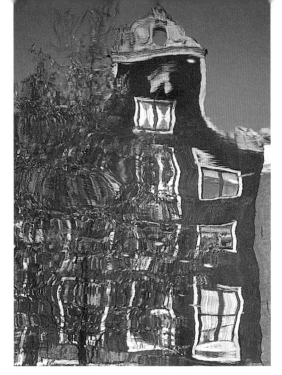

A STRETCH OF WATER is always worth hunting out as a foreground for your photographs. The surface of a lake, river, pond, or even puddle, will create its own image of the subject in front of you. If the surface of the water is perfectly still, the reflection is a perfect copy of your subject. A rippled surface, on the other hand, creates a distorted, or abstract, view of the scene. Either way, the reflection gives you an alternative view of the subject.

There are two approaches to photographing reflections. You can aim to include both subject and its mirror image – creating a feeling of harmony that suits some subjects well. However, the perfectly balanced design can be too symmetrical on other occasions. The other approach is to photograph the reflection alone. This creates a more mysterious view of the subject – particularly if the surface of the water is not completely flat. When presenting these shots, you have the option of showing the picture as you shot it – or being more devious by turning the composition upside-down.

Distorted view

The reflection of an Amsterdam house; this time including the house itself would have been repetitive. Turning the shot upside-down, rather than showing it as seen, makes the picture more challenging, as it is less obvious that you are looking at a reflection.

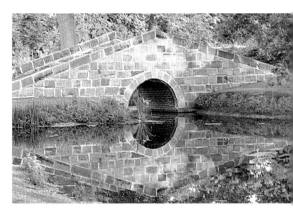

Water feature

Ponds are deliberately used by gardeners to reflect the structures and plants around them – so it is worth including both in your shots.

Mirror image

For perfect reflections you need the water to be perfectly still. When photographing the fjords of Norway, I found the best time for this was either first thing in the morning or at sunset.

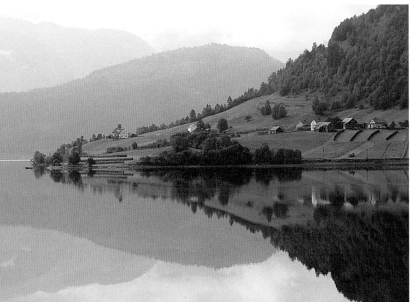

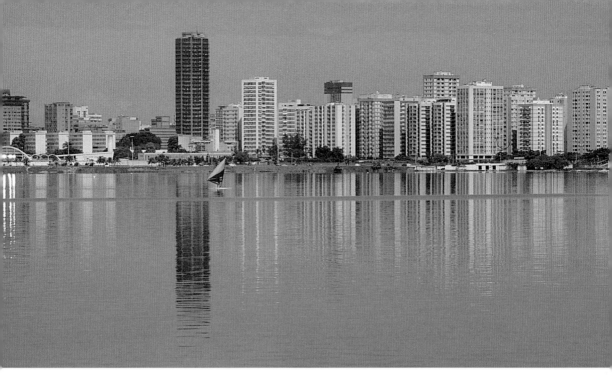

Double value

A gentle breeze means that two slightly different views of the Rio de Janeiro waterfront are combined in a single frame. First there is the high-resolution image of the buildings themselves, and below is the feathered, diffused image of the reflection.

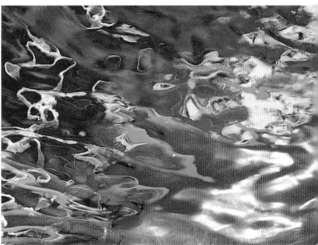

Abstract approach

A reflection of a brightly painted fishing boat on the Mediterranean creates an image with an abstract design and the depth of colour that is reminiscent of a modern painting.

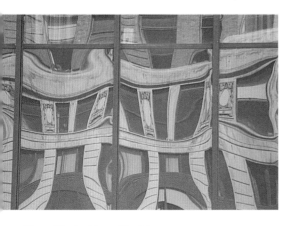

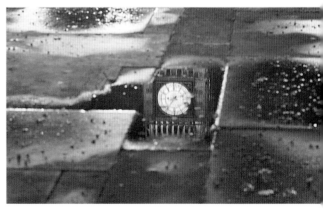

New York, New York!

Modern offices often use highly reflective glass that mirrors the buildings around it – allowing different architectural styles to be combined in a single shot.

Time to reflect

You don't need a lot of water for a useful reflection. A puddle was all that was needed for a highly unusual shot of London's Big Ben after dark.

Star bright

Flare is normally frowned on by photographers – but with a
small aperture it helps turn the sun into a picture-book star

Exposure variations

Taken on the Greek island of Mykonos, these two
shots were taken within minutes of each other. I
wanted a silhouetted shot of the church – but the
only viewpoints I could find meant including the sun
in the composition. Using an aperture of f/22, the
sun has been turned into a pointed star. With the
exposure compensation dial of my camera, I was
able to alter the overall exposure of the shot – and
therefore take a series of shots with varying
intensities of blue in the sky.

MOST PHOTOGRAPHERS AVOID including
the sun in their photographs, unless
shooting at dusk or dawn. There are two
very good reasons for this. First, it can be
dangerous to look directly at the sun.
Second, there is the danger of flare. Despite
the modern lens coatings, and the use of
lens hoods, there is always a risk of light
from the sun reflecting in an uncontrolled
way inside your lens – creating streaks of
light across your picture. Frequently this
flare includes one or more hexagon shapes –
formed by the shape of the aperture. There
are times, however, where flare has its uses
in your pictures. In particular, it can help
create a feeling of intense heat – which
could be of particular use if you are trying
to convey the high temperatures at your
holiday location.

One good way to exercise some control
over the the flare in the picture is to use the
smallest apertures available on the lens you
are using at the time. With these, the
diaphragm effectively works like a starburst
filter (see page 28). The sun is turned
therefore into a many-pointed star – which
can add further interest to the shot.

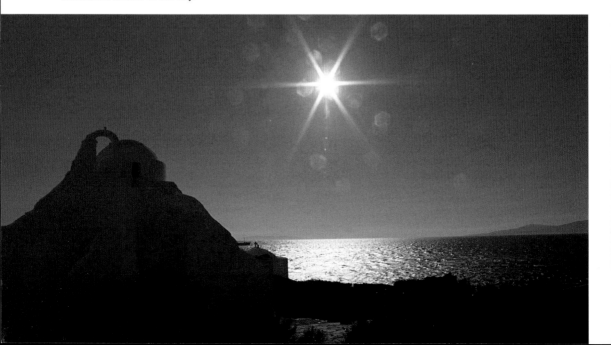

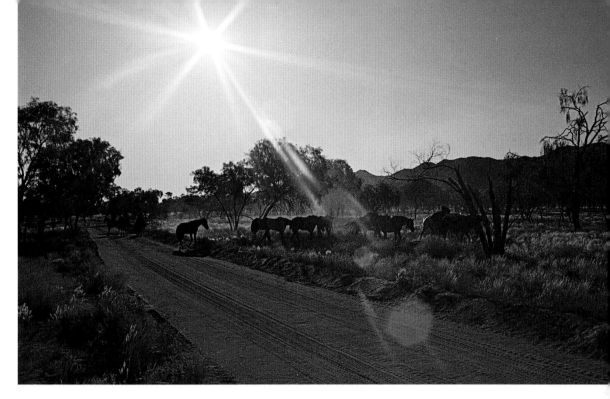

Heat and dust

The scorching heat of the Australian outback is portrayed by including the sun in this shot (above).

Starry eyed

In the shot below the starburst effect has been placed to look as if originating from the man's eyes.

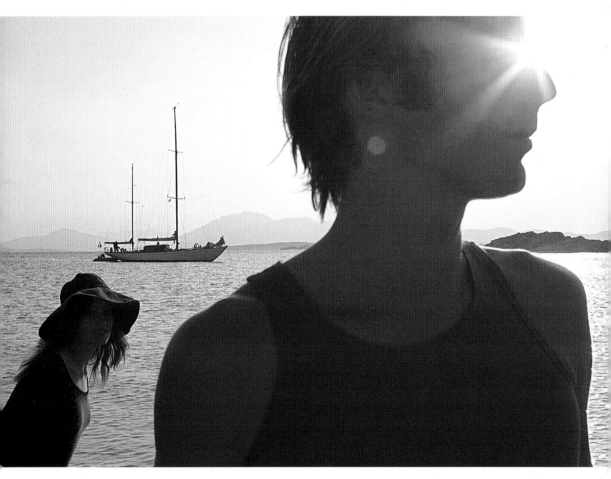

Distant views

When photographing famous landmarks, you often get better compositions and fewer crowd problems if you don't get too close

Many of the places that you will want to photograph on holiday will be popular tourist sites. You not only have to cope with fellow sightseers getting in your way; you have to avoid the ice-cream kiosks, ticket booths and coach parks that will undoubtedly ruin your pictures.

One of the best solutions to this problem is to photograph your destination from a distance. Many of the world's best landmarks can be seen for miles – and seen from that far away the commercial side of the site and the crowds become invisible.

Such pictures demand making a special effort. You have to travel around the site to find suitable viewpoints – on foot or by car, or by begging the bus driver to stop. But the added advantage of this approach is that it's possible to include a wide range of different foregrounds – so that you come home with some truly original compositions.

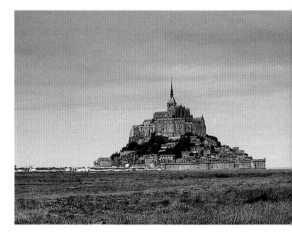

Mont St Michel, France
The pictures on these two pages are all of the same famous French landmark shot from a distance.

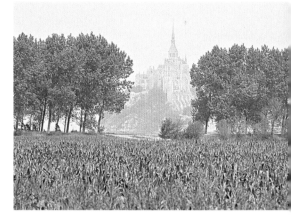

Haze and maize
A gap in a row of poplars makes a great frame for the distant monument; the cornfield fills the foreground.

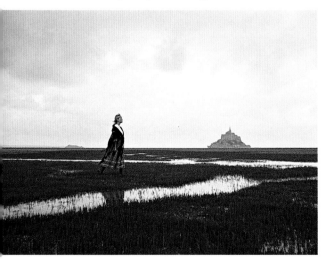

Easily identifiable shape
The island is still recognisable even when small in the frame, so even wide-angle distant shots are feasible.

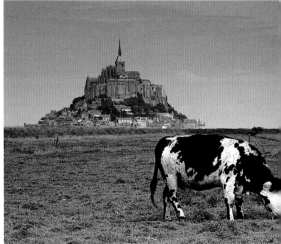

Complementary addition
Look for foreground subjects that are photogenic in themselves. Here a Normandy cow does the trick.

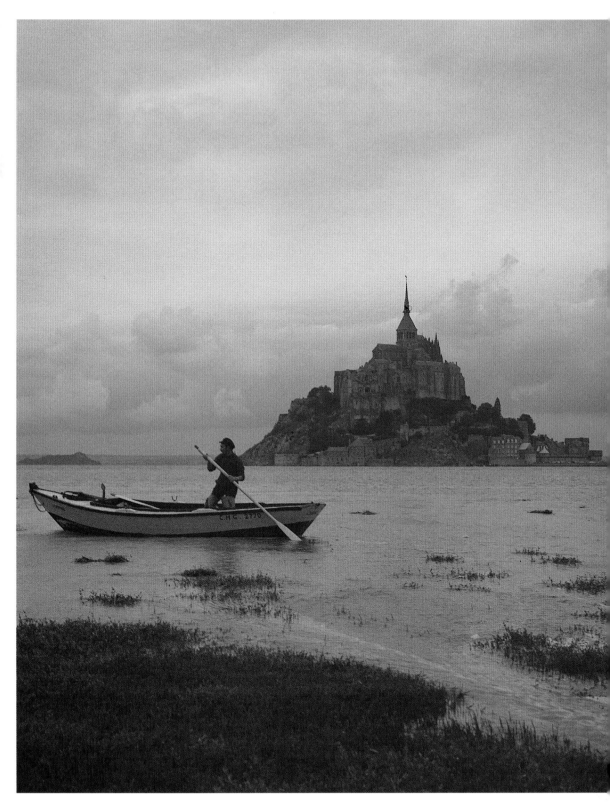

Set-up shot

Don't be afraid to engineer a shot. I had to persuade this boatman to move into
the right position to secure this unusual low light shot of Mont St Michel.

Using diagonals

Getting key lines in your shot to run at an angle is one of the simplest ways of making your shots more dramatic

All action

Shots of action subjects work particularly well when positioned so they seem to move diagonally across the frame – as this helps give an impression of movement.

PHOTOGRAPHIC COMPOSITION is simply a matter of arranging the elements in an order, to make it clearer what you are showing. There are no hard-and-fast rules – but there are proven ways of making your picture look that touch more dynamic.

One of the simplest of these is to put your subject slightly off-centre – the lack of symmetry creating a more dynamic picture. Another, and lesser-known, trick is to use diagonal lines. It is tempting to arrange your subject so that the lines of a subject run parallel with the sides of the picture. With some elements in a picture, this is almost essential. If you tilt the horizon, so that it appears anything other than level, your pictures can look very peculiar. But, keeping all the lines within a picture square with the frame results in shots that are predictable (if not plain boring). ☛

At close range

By getting closer you can make horizontal lines appear angled – as with the top of the wall here of the gardens of Schloss Schwetzingen, Germany. Notice that the statue still appears perfectly upright.

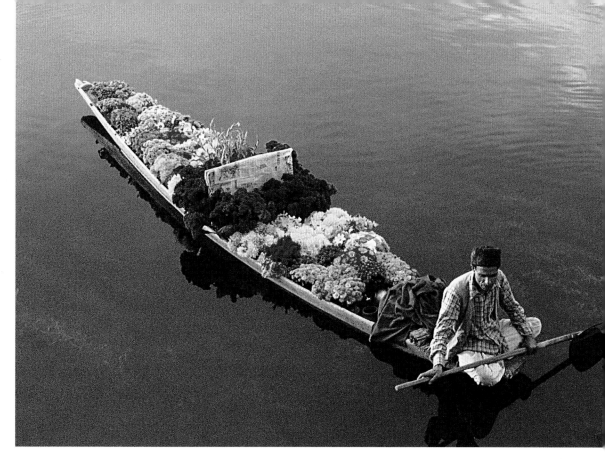

Choice of angle

Shooting from above with a plain background, it would have been possible to shoot this picture of the floating flower seller so that the boat was at any angle. Lake Dal, Kashmir, India.

Double diagonal

Shot in Saumur, France, the angle of the small river island is mimicked by that of the boat.

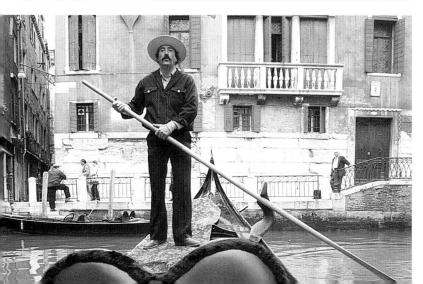

Out of the corner

It was timing, rather than viewpoint, that allowed me to frame this shot of Venice, Italy, so that the gondolier's pole appeared from the corner of the frame at an almost perfect 45°.

Using diagonals continued

The reason why diagonal lines work well within a picture is simply because they don't run parallel or perpendicular to the sides. They break from the mould, as it were, and therefore immediately attract the eye in a composition.

Diagonals can therefore be deliberately placed in a picture so that they lead the eye through the shot – or take you towards the main subject matter.

Angled lines can be found naturally in most situations – and, once discovered, you frame them so that they create a bigger angle with the sides of the frame. With a single line, the most dramatic results come when the line comes into the frame from one of the corners at 45° to the sides.

In some situations it is possible to turn horizontal lines into diagonal ones, without the verticals slanting. To do this, all you need to do is to get closer to the subject and use a wider lens setting – the change in perspective will do the rest. This is a particularly rewarding approach when shooting architectural details.

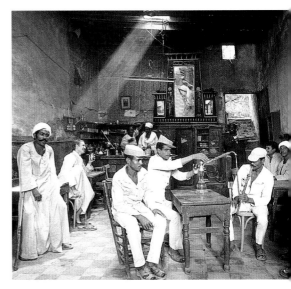

Flash of light

An everyday scene in Cairo (above) has been transformed by a beam of light breaking across the roomful of men.

Leading the eye

High contrast meant that the foreground in this Egyptian scene (below) was rather empty – the strong diagonal, however, leads you to the main part of the picture.

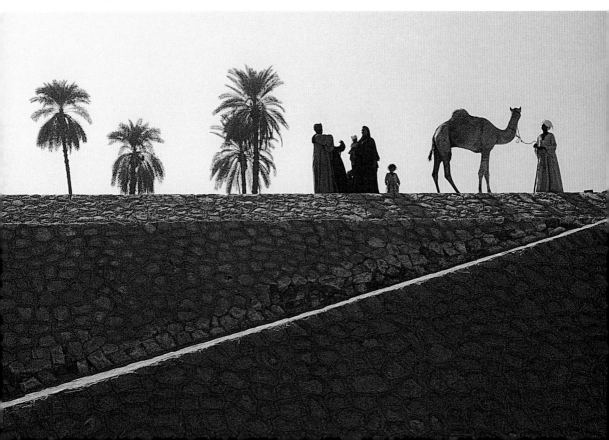

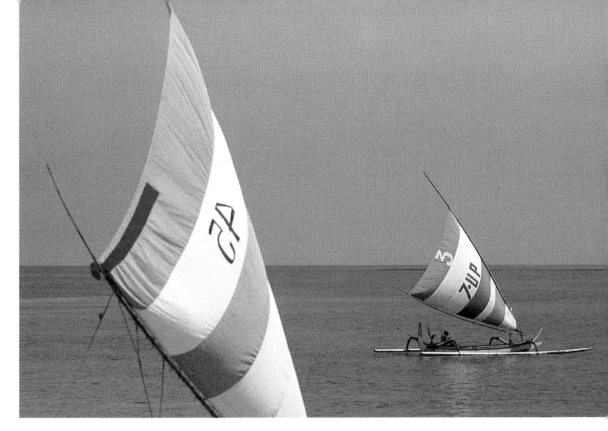

Multiple angles

The triangular sails of these Indonesian boats (above) make great subjects because of the number of diagonal lines they provide. When you have more than one diagonal line, you get the maximum effect if the diagonals each form different angles with the side of the picture (as in the picture left, taken in France).

Light and dark

The streak of light across an Egyptian beach in the shot on the right was created by a gap between two buildings late in the day. To maximise its impact, I arranged the shot so it appeared from the corner of the frame.

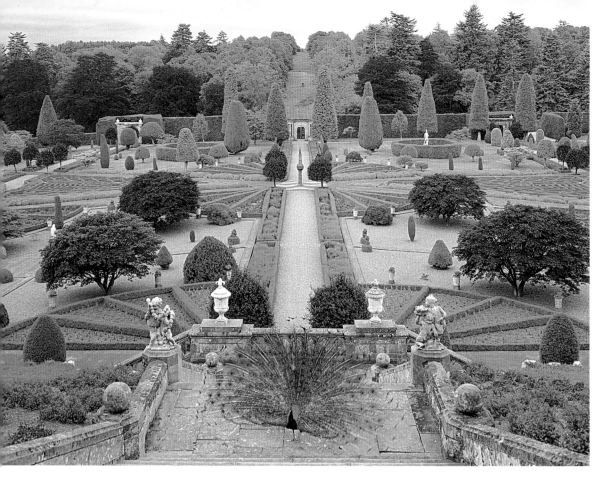

Perspective

Because photographs are flat,
photographers need to learn all the
different tricks that can be used to
suggest the missing third dimension

ONE OF THE MAIN SKILLS of the
photographer is in trying to show
depth in a flat photograph. A whole range of
compositional devices can be used to help
show that some things were further away
from the camera than others.

One of the best known of these is linear
perspective. Parallel lines seem to converge
as they recede into the distance – and this
effect can often be accentuated by standing
closer to your subject, and using a wider
lens than you might otherwise use. But
there are other types of perspective (shown
on these pages) that can be used, often in
combination with each other, to help the
viewer appreciate depth and distance.

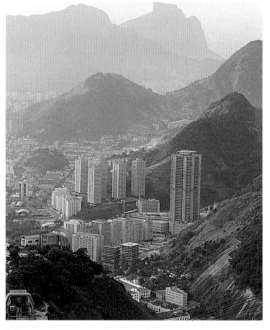

Linear perspective

Converging lines of a
path tell us that the
narrower parts are not
narrower – just more
distant. Drummond
Castle, Scotland (top).

Aerial perspective

Dust in the air makes
things further away
appear paler and less
distinct than those which
are closer to the camera.
Rio de Janeiro, Brazil.

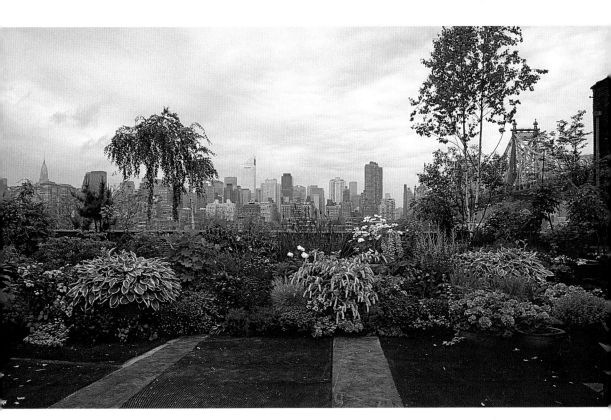

Overlapping forms

The foliage of this New York garden partly obscures the Manhattan skyline behind. We know that the thing we see completely is closer than the one that is partly hidden – so the garden is closer to us than the city. Such things may seem obvious, but thinking about these things helps to create photographs that appear more three-dimensional.

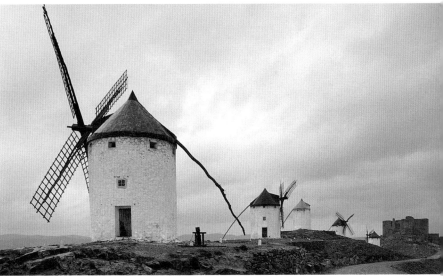

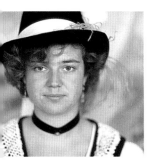

Selective focusing

Photographers can use depth of field as a way of making things appear distant. In this shot of a German woman in national costume, we assume the background is distant, because it is out of focus.

Diminishing size

Many of the visual skills that we learn at a young age can be used effectively to show distance in a flat photograph. We can be fairly certain, experience has taught us, that these windmills are of similar size – but some appear much smaller than others, because they are further away from us.

Scale

Placing something, or someone, of a known size in your composition can help show the size of the unfamiliar things in your composition

FREQUENTLY WHEN YOU VISIT places you have seen only in pictures before, you are surprised that they are so much bigger or smaller than you had expected. A photograph can fit a mile-high mountain into a frame, of course – and without knowing the subject's exact distance and the focal length of the lens used, the exact size of any subject can be only a matter of conjecture. Few people will realise the extent of the Grand Canyon, for instance, if they have not seen it for themselves. It is very easy, however, to give the people who see your holiday pictures a better idea of scale – particularly when visiting a landmark that appears particularly large.

The way to do this is to include something within the frame of a recognisable size – a human figure is the most obvious choice. The scale object must be close to the main subject, however – otherwise variations in perspective make it almost impossible to use accurately.

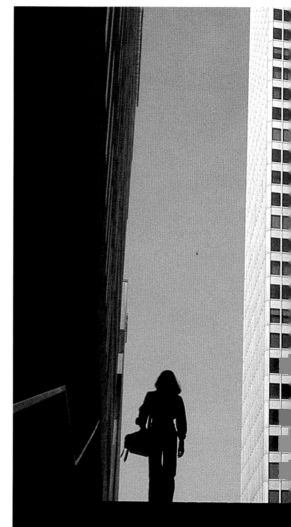

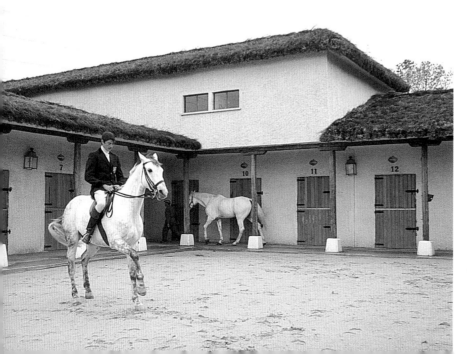

Sense of size

The silhouetted figure in this shot of a Toronto skyscraper doesn't just give an idea of scale – it suggests the feeling of being towered over we all feel when looking up at tall buildings.

Visual clues

Most pictures give the viewer scale objects to work with. Here the rider provides an idea of the height of the horse, whilst the other horse tells us about the size of this Spanish stable yard.

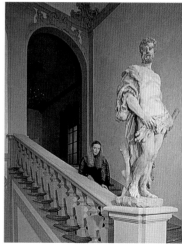

Comparative figures

The presence of the woman on the stairs gives us an idea about the size of the statue. However, as both are at different distances, it is not possible to be entirely certain.

Yellow ants

It is only when you realise that each of the yellow blobs in this picture is a person that you appreciate the huge power and size of Niagara Falls.

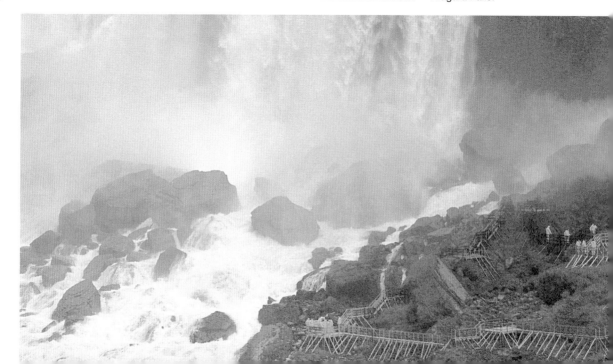

Leading the eye

Natural paths can be used as the spine for your photograph – linking the different elements together, and leading the viewer through the composition

TRACKS, ROADS, PATHWAYS, RIVERS, railways – thoroughfares both natural and manmade are important compositional devices in photography. Their straight lines can be found in practically every landscape, and lead to every monument. Their appeal is the way in which they can guide the viewer's eye. When people look at a photograph, their eyes do not remain fixed: they flit from point to point, scanning for things of interest. A line connecting the foreground to the background in a landscape – or drawing you to the main subject of your shot – then acts as a route for the viewer to follow (subconsciously) through the picture. These routes are, of course, an excellent way of adding linear perspective (see page 54) and diagonal lines (see page 50) to your composition.

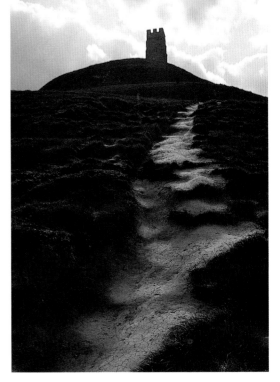

Well-trodden path
The steep footpath leading to the top of Glastonbury Tor, Somerset, provides an ideal way of leading the eye through the picture.

Downtown view
An unusual view of New York, with the wide road seen from above. You cannot help but follow the route upwards to the horizon.

Golden road
The warm evening light reflects nicely off the road, creating a central focal point for this Icelandic scene.

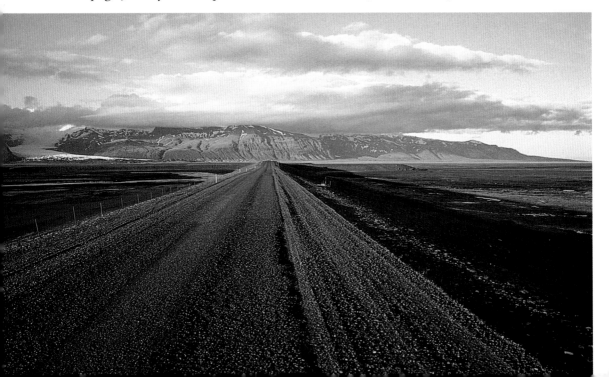

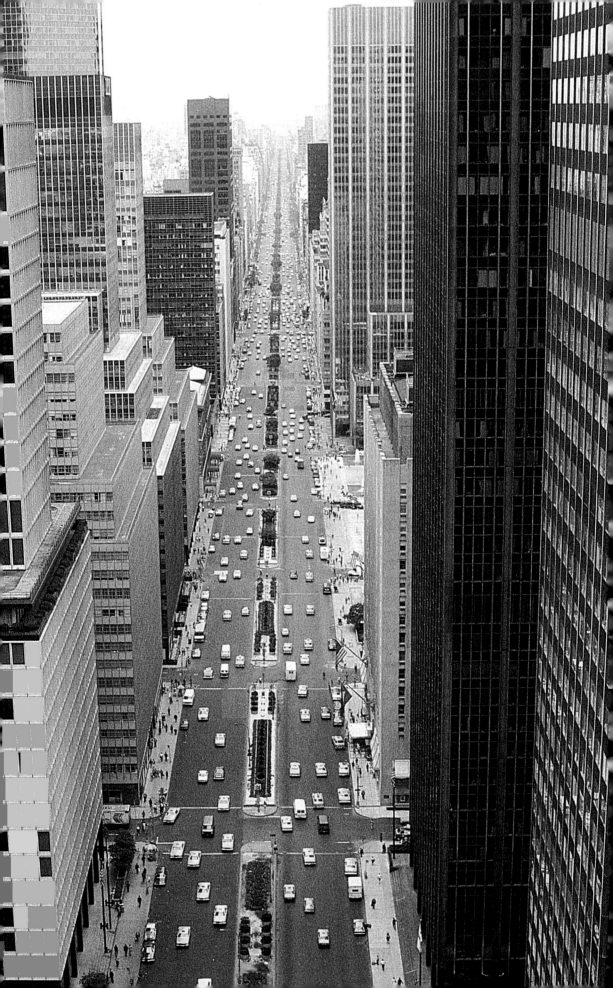

Frames in frames

Natural frames allow you to change the effective shape of your pictures, as well as helping you to lose the crowds and to add a feeling of depth to your shots

A CAMERA PROVIDES an artificial border to your pictures, and whilst this format might be made to suit most subjects, it won't work with all of them. Often you are faced with having a bland foreground in the shot, because the subject does not fill it well enough. One way of avoiding this is by using a natural frame – such as an archway, or a gap between two trees, which will create a secondary window within which to compose your picture. Once you start looking, you will find that most scenes can be framed in this way.

This compositional approach has other advantages too. In busy tourist places, it can often be a good way of losing the crowds from the foreground of a picture. The technique also provides a way of adding depth to a picture – which is particularly useful when photographing the flat front of a building.

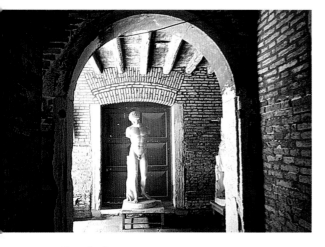

Spy hole
Natural frames add depth. Here we get a feeling of looking along a corridor to the statue at the end.

Hiding the tourists
Out-of-focus drapes on a stall made an impromptu way of hiding the other visitors to this site.

Partly framed
A natural frame does not have to have four sides – here the building in the foreground effectively narrows the picture format by cropping two sides.

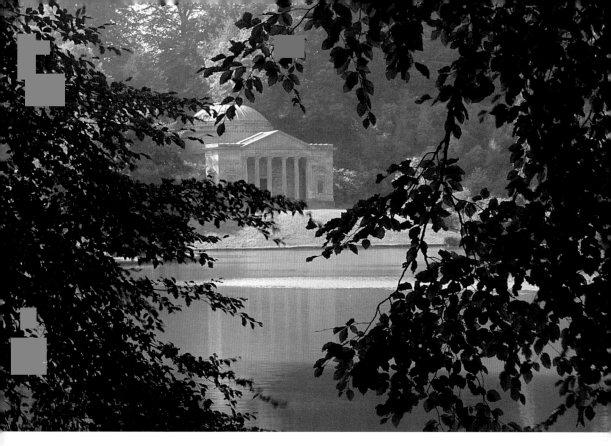

Foreground filler

A large open lake made for a rather empty foreground for this shot of the gardens of Stourhead, England. Finding a more restricted view, through the trees, makes for a more interesting composition.

Frame as subject

Sometimes the frame you find merits more than being a compositional device, and is worthy of being a subject in its own right. Here the elaborate archway is more photogenic than the ruins beyond.

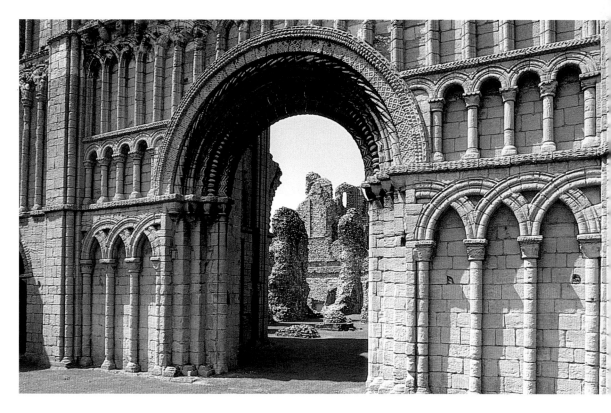

Round the bend

The curves of rivers and country roads are the natural way to lead the eye across a picturesque landscape

IN MANY WAYS, curved lines can be used within a composition in the same way as straight ones. The primary role for both is to lead the eye through the picture (see page 58). But there are subtle differences in the effect they have. A curve is probably the most visibly pleasing shape that you can incorporate in a shot. Not only do curves have natural grace, they also seem to suggest movement – especially when the line twists this way and that in an S-shape.

A snaking river or country lane winds its way across a landscape, splitting up the frame in a subtler and more peaceful way than a diagonal. Curves are therefore very useful when photographing a tranquil landscape where a more dynamic straight line might seem out of place. S-bends cannot be manufactured (unlike diagonals, see p.50) – they are either there or they are not. But when you do find one, you can make it more prominent in your shots by using as high a viewpoint as you can find.

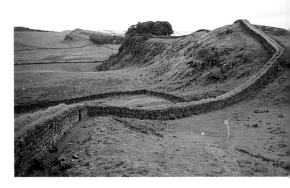

Ancient division

In this shot, it is the bend itself that is the main subject for the picture. Hadrian's Wall was built by the Romans 1900 years ago, but much of it still can still be found snaking its way across northern England.

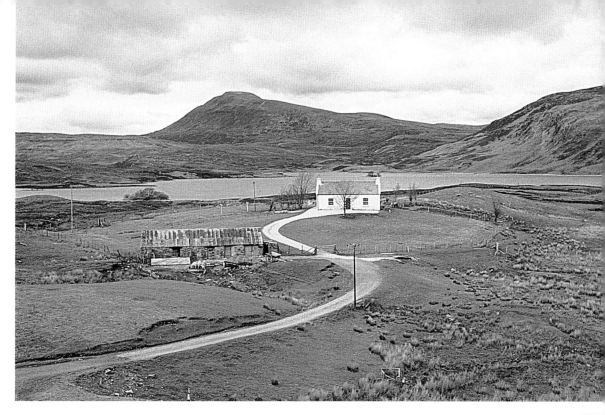

Taking the high ground

S-bends often become more apparent in a landscape when observed from an elevated viewpoint.

Architectural curves

Interesting curves can be found in many subjects other than landscapes. To maximise the impact of this spiralling staircase, I had to lie on the ground so that the lens pointed straight upwards.

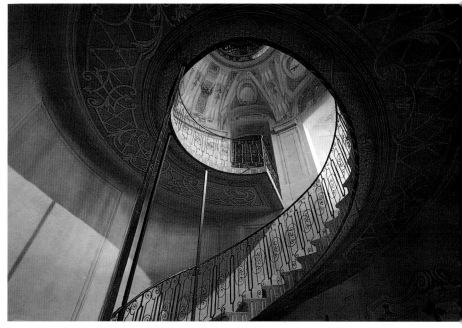

Choice of roads

Sometimes the curve itself can form the main subject for the picture. A conifer forest alone offers limited potential – but the road with its choice of routes creates a curving shape that contrasts with the straight pattern of the trees.

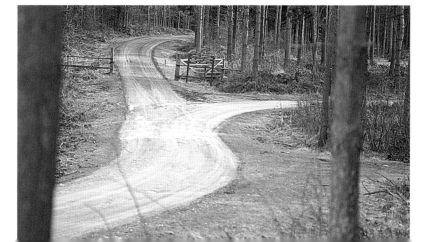

Up and down

Try not to shoot all your pictures from normal eye level – often you can improve the shot by getting down low or seeking a high vantage point

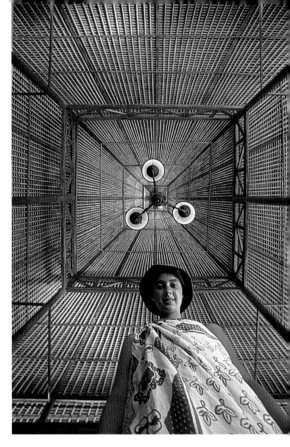

Whilst exploring a new location, you naturally walk round the subject looking for the best angle and the most favourable light. It is rather harder to get into the habit of trying to see if varying the height of the camera improves the composition. Inevitably, most holiday pictures are shot from head height, with our feet at ground level. But by getting down on your knees occasionally, or even lying on the floor, you will discover different approaches to a subject. Similarly, climbing up on benches, or looking for buildings that afford an elevated vantage point over the subject, will provide a more varied selection of vacation pictures.

Changing camera height is also a great way of eliminating distracting backgrounds – often allowing you to use the sky or the ground as a plain backdrop to the shot.

Standing tall

Using a low angle for portraits makes them look superior, and taller, but here the attraction was being able to use the patterned ceiling as a backdrop.

Vantage points

Be on the continual lookout for bridges, balconies and banks that will give you a high viewpoint.

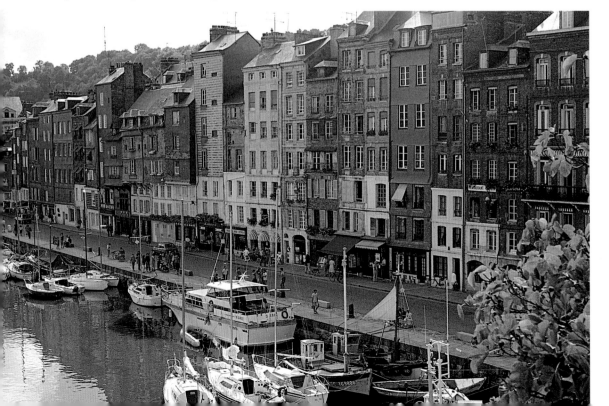

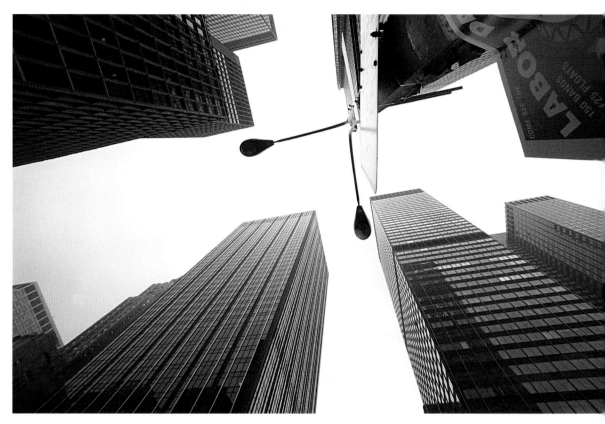

Up to the sky

The traditional approach with skyscrapers is to point the lens upwards with a wide-angle lens – so that you fit most of it in, and get the characteristic converging verticals. But by lying down, and using a 20mm lens I was able to take this approach to its extreme.

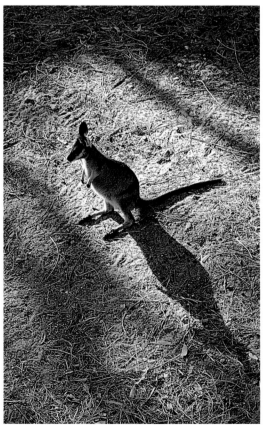

Aerial approach

Modern zoos are designed to give you more interesting views of the wildlife they look after. The advantage of the viewing platform for this shot of a wallaby, is that the ground creates a plain backdrop – unspoilt by wire fences.

On my knees

Kneeling down created a far more interesting shot of this statue than I would have got if I had shot from head height.

Capturing the moment

With action subjects, you have to take the picture at the right moment if you want to capture the essence of the event

Timing is the key to photographing action. Click the shutter at the wrong moment and the photography is lifeless; shoot at the right time and you capture the essence and excitement of what is going on.

Everyone knows what these moments are in their favourite sports – it could be the second that the sprinter lunges for the finishing line, or the concentration of the batsman as he makes contact with the ball. But all moving subjects have these high points – including any social gathering or live event – which when caught on film seem to capture the energy of the occasion.

You must learn to anticipate these picture opportunities as they develop – and have your camera ever-ready, so that there is no delay between seeing the moment and shooting it. You will have many more failures than successes with this sort of shot – but the one or two that succeed make all the investment worthwhile.

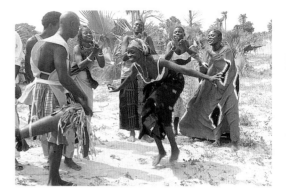

Beach party, Gambia

Attracted by the music, I managed to capture this woman doing her impromptu dance with her feet completely off the ground. I avoided freezing movement completely with a 1/125sec shutter speed.

Riding school, near Dublin, Ireland

Not only have I caught the riders mid-jump, but in doing so they have framed their on-looking trainer. I used a 21mm wide-angle and a speed of 1/1000sec.

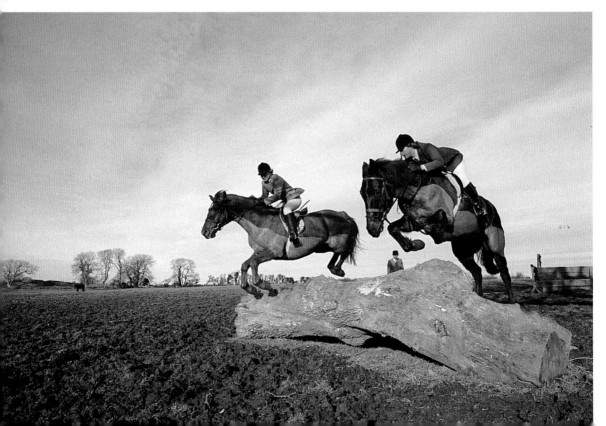

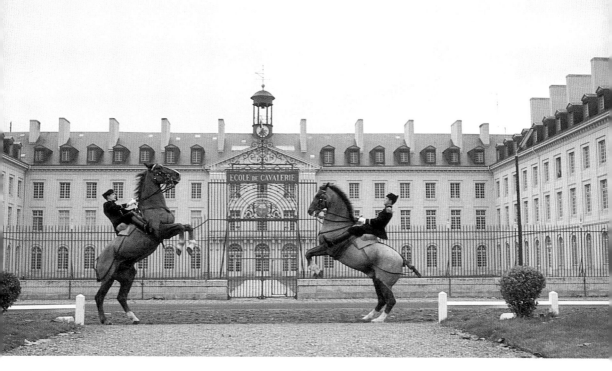

Cavalry School, Saumur, France

The guards performed this ritual once an hour, so I had to ensure I was ready for the crucial split second when their great horsemanship was so well captured in a single 1/500sec exposure.

Fell runner, Lake District, England

Timed against the clock, there are no obviously dramatic moments in this sport – the magic of the event is in the breath-taking scenery. I found this spot with shaft of sunlight breaking across the water, and waited for a competitor to run into it.

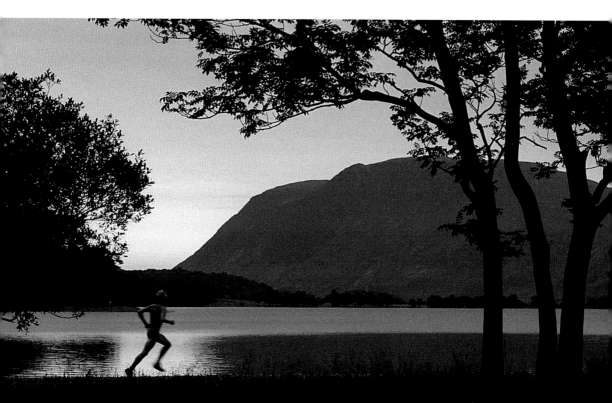

Echoing shape

Foregrounds are not just important as space fillers; they can
be made to work closely with the landscape subject itself

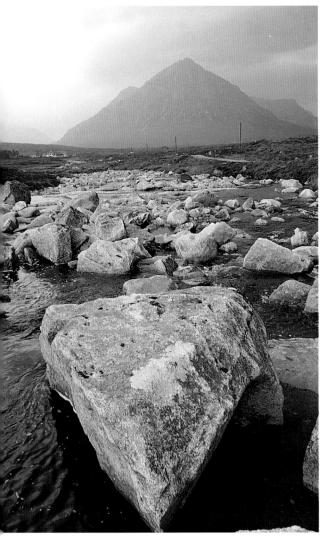

THE PROBLEM WITH USING WIDE-ANGLE LENSES to capture the landscape or cityscape in front of you is that frequently you are left with an expanse of featureless, or unsightly foreground. The solution is to find something that you can stand just behind to fill this space – an interestingly shaped boulder, a rustic fence, a colourful flower and so on. Once you have started developing an eye for finding these fillers, you will begin to find occasionally that the foreground is so successful in complementing the picture, or is so interesting in its own right, that your original subject matter becomes little more than an elaborate background. Give in to the temptation, and let the foreground dominate – as this will ensure you a more original, if not more interesting, picture.

Stone symmetry

The large rock in this river bed seems to mirror the shape of the mountain in the distance.

One man's rubbish

An old tyre provides an unusual foreground for this shot taken in Bugle, Cornwall, England.

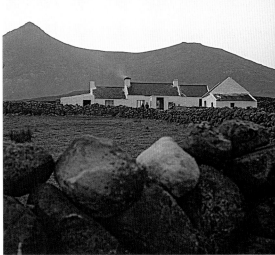

Triple triangle

I was particularly pleased to find this solitary triangular rock so well placed in this Irish landscape – as it mimicked perfectly both the roof of the house behind and the mountain in the distance.

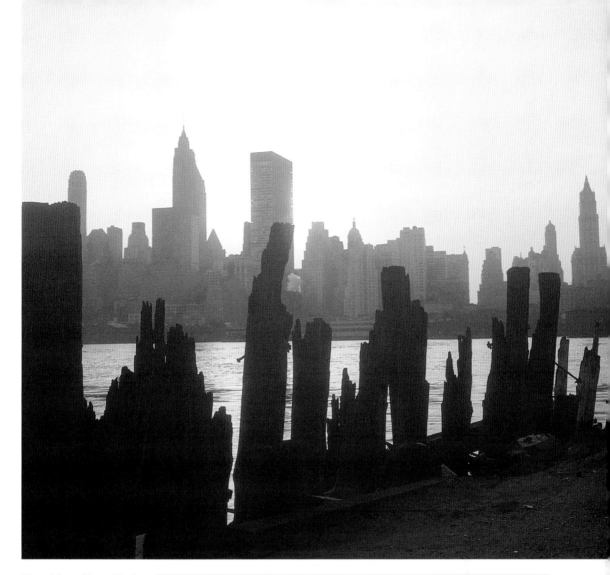

Brooklyn, New York

I couldn't help but notice how similar in stature and shape the battered timbers of the wharf were to the skyscrapers of Manhattan on the other side of the Hudson. To bring them close enough together in the frame for the viewer to see the association, I used a 150mm lens and an aperture of f/16.

Light and dark

In this Scottish landscape, I like the way in which the white house contrasts against the black silhouette of the mountain behind.

Chapter 3
Picture opportunities

Cathedrals and churches

Religious buildings dominate the skyline of many cities, towns and villages – but they offer great picture opportunities on the inside, too

WHATEVER YOUR OWN beliefs, you cannot help but admire the buildings that have been constructed in the name of religion. They are frequently the tallest, oldest and most opulent buildings in any place that you visit. From the outside, they become obvious focal points for any cityscape or landscape that you shoot – and they make imposing shots when pictured on their own. The greatest treasures are often to be found within their doors. Ornate decoration is everywhere – in the stained glass, in the vaulted ceilings and in the worn gravestones under our feet.

As with most interiors, one of the main problems you have to overcome when inside a building is the low light – making handheld pictures difficult to take. ☞

Raised viewpoint
All the pictures on these two pages, and the following two pages, are of Canterbury Cathedral, Kent, England. Here I gained access to the roof of a neighbouring building – this let me fit the huge structure into the frame with minimal distortion.

Waiting for the right moment
Wide-angle shots inside churches often require you to be patient, waiting for people to wander out of the shot. It took several attempts for this shot.

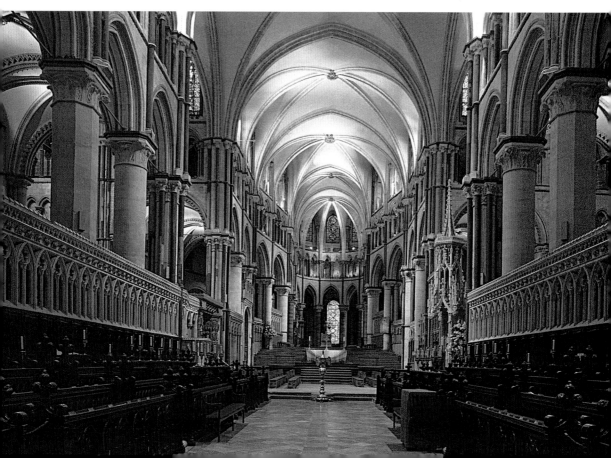

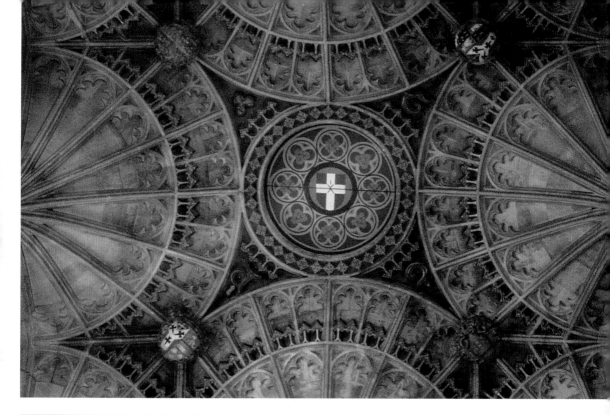

Vaulted ceiling

Sometimes the best pictures of churches are those taken with the camera pointing straight upwards – as with this shot of "Bell Harry", Canterbury Cathedral's central tower. To ensure the camera is well supported you could lie down yourself; alternatively place the camera on its back on the ground, firing it with the self-timer to avoid any vibration.

A quiet spot

It is the lighting that makes this photograph – but the problem was finding a place where I could take a picture without being disturbed. I managed to set my tripod up in an alcove so I was out of people's way. Although many public buildings discourage tripods, you can often use them if you get special permission and pay a small fee.

Cathedrals and churches continued

Without a tripod, you will be forced to do the best you can with the fastest film you have with you. Use the things around you to give the camera added support – so that you can use a shutter speed that is two to four times as long as normally advisable for a handheld shot. Sitting down on a pew or a stair is a great way of steadying the camera, for instance. Alternatively, sit the camera itself on a ledge or a table when shooting. When standing, you can help keep the camera more rigid by leaning hard into a doorway, pillar or wall.

Cloister ceiling, Canterbury Cathedral

I used a monopod here to give me more latitude with shutter speed, so I could maximise depth of field.

Edward, the Black Prince

I stood above this tomb to get a close-up view of one of Canterbury Cathedral's more famous tombs.

In the frame

I used a 28mm shift lens for this picture, so that I could accurately frame up one side of the cathedral cloister from one of the archways on the other side.

Tomb of King Henry IV

The gravestones found in and around churches often make great photographic subjects – particularly when weathered and worn by time. The tomb in this picture dates back 600 years – and is far more ornate than the average headstone. This is an unusual view, as the tomb is not usually seen from above. If you ask for the cooperation of staff and volunteers you can often get access to restricted areas, or be allowed to borrow stepladders, so as to get different camera angles.

Gatehouse

It is very tempting with architectural shots to always endeavour to get everything in. But the beauty of architecture is often in the detail, and this can only be seen properly in close-up. This doesn't necessarily mean you have to use a long lens, though; for this shot of the gatehouse of Canterbury Cathedral I used a 28mm shift lens.

Stained glass

The problem
Colourful windows make great photographic subjects, but if you are not careful the glass can appear colourless and overexposed.

Fill the frame
The contrast range for this sort of shot can be too great for the film to cope with – if you include both the dark walls and the bright windows in your composition. The exposure meter makes a compromise and the windows can end up being severely overexposed. The simplest solution is to zoom in so that the windows fill as much of the frame as possible to avoid exposure errors.

Parks and gardens

Gardens are the perfect places in which to get pictures
packed with colour – and you don't even need a sunny day

Specialist equipment

I used a 100mm macro lens (see page 78) for this
close-up of this dew-covered rose.
Longwood Gardens, Pennsylvania, USA.

EVERYONE THINKS OF gardens as the place
to be on a sunny day – but this is rarely the
best time to photograph them. Filled with
flowers and detail, gardens are generally
complex scenes, which when lit with direct
light become a confusing mass of shadows.

The ideal lighting for most garden shots
is strong but diffuse lighting. The best time
for this is early in the morning – or late in
the afternoon. Fortunately, for those on a
tight travelling schedule, you can get the
same sort of results by waiting for the sun to
disappear briefly behind the clouds. As
many of the best gardens in the world are
found in temperate climates, you rarely
have to wait long.

Gardens are moving subjects – with
foliage and flowers that refuse to stay still in
the wind – so you must choose the shutter
speed with care. For close-ups it is handy to
take wire stakes to keep individual blooms
steady for close-ups, or use a sheet of ☛

Men at work

The figure of the
gardener gives a sense
of scale in this shot of
the tower at
Sissinghurst, Kent,
England. Taken with a
28mm shift lens.

Overcast day

Bright sunlight rarely
works well for shots of
flowers, as the shadows
over-complicate the
scene and obscure the
colour. This shot above
was taken when the sun
was hidden by cloud.

The Flowerpot Men

Flowers can be planted or arranged in the most unusual ways. These elaborate or innovative designs can make interesting pictures that will add fun to your holiday album. I spotted this design on the island of Jersey.

Tele approach

To be able to show the way in which different species and varieties are planted together in a bed, you need to use a telephoto lens from a distance. This squeezes the different planes together, allowing you to fill the frame with colour. For this shot of an English country garden, I used a 150mm lens. Oxnead, Norfolk, England.

Sunny days

Strong sunlight will work with simpler compositions – or where you want to give an effect, rather than show detail. In this shot it is the blossom on the tree, the path and the blue sky that are the main focal points – and these all stand out well with the sun directly behind the camera. Taken in Edgecombe, Hampshire, England.

Parks and gardens
continued

cardboard as a windshield. If white, this sheet of card can also be used a reflector, softening the shadows in any close-up.

On a short visit to a garden it is impossible to take good pictures of everything – some things will undoubtedly look better at different times of year, or in different weather conditions. Concentrate on the subjects that do look at their best.

Macro equipment

Individual blooms
For close-up shots of individual flowers you often find that your usual lens will not focus close enough to get the magnification you want. A variety of different equipment can help SLR users in such situations.

Macro lens
Expensive but best all-round choice, offering variable magnification up to life-size reproduction on film (or imaging chip). Available in different fixed focal lengths – but 90mm or 100mm is the most popular choice, as this gives the best working distance for most miniature subjects. Can also be used for 'normal' subjects.

Close-up attachments
These fit like filters to the front of an existing lens, and work like a magnifying glass. Available in different strengths, although the maximum magnification is limited. A low-cost, lightweight solution for the traveller.

Macro zooms
Many zooms offer macro settings – but the actual magnification offered by these is very variable. Some are useless. The best may offer images on film that are up to half life-size – but the drawback could well be that this facility is only available at long telephoto settings (so it is hard to keep the lens steady, and you are also a long way from the subject).

Extension tubes
Hollow tubes that fit in between the SLR and a normal lens. Normally sold in sets of three, these can be used singly, in pairs, or all together giving a variety of different magnifications. More fiddly to use than a macro lens, but can produce life-size images.

Garden of monsters

Hard landscaping in gardens is as important in garden design as the flowers, shrubs and trees. In the 16th-century garden of Bomarzo, Italy, seen in these shots, the parkland is punctuated with outrageous statues of monsters, animals and gods. Like all gardens, a view that looks dull one minute can be brought alive by the exciting way light strikes the garden.

Castles

Castles are more than just grand buildings – and it is up
to the photographer to show this in his or her pictures

THE CHALLENGE WHEN photographing castles is not just to make your shots interesting, but to try and capture something of their historical significance. They are not just impressive buildings, for instance; they are military fortifications, built in strategic locations. Often built at the top of hills at the side of a river, they naturally look at their best when seen as part of the landscape. And then there is the pomp and ceremony of castles... ☛

Overlooking the scene
A view from the top of the gatehouse gives a good view of the layout of Caerphilly Castle, Wales...

Additional interest
...but the same viewpoint is given more meaning with the addition of the marching soldiers.

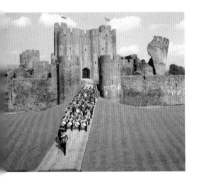

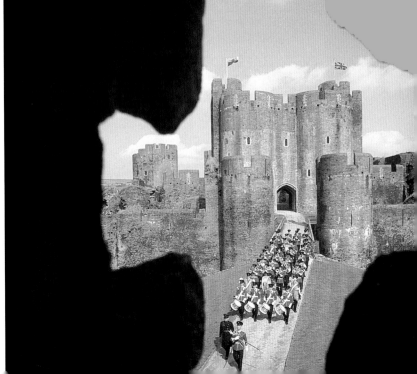

Alternative angle
The above shot shows Caerphilly Castle and marching band well – but the grass in the foreground is rather featureless. Framing the shot through a hole in the wall (right) makes a tighter composition.

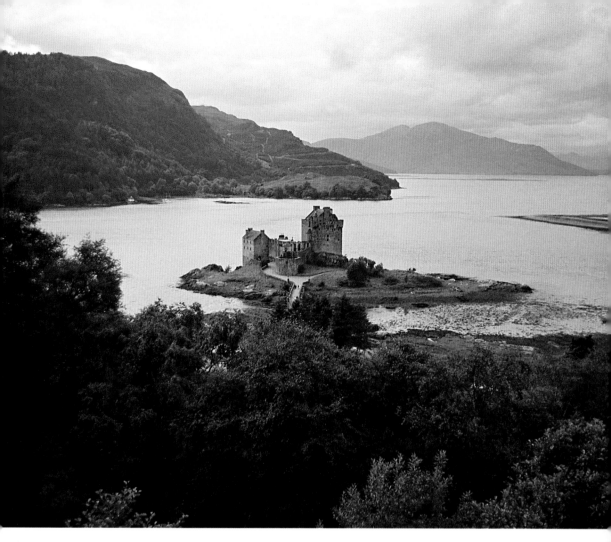

Location, location, location

It is the position and surroundings of Eileen Donan Castle that have made it one of the best-known castles of Scotland. A distant view that includes the mountains and loch is essential to a successful shot of the building (above and below).

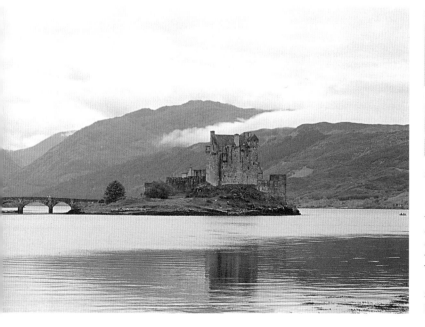

Sunset reflections

Moats have great photographic appeal, as they allow you the option of double images of the castle, or showing the reflections alone. This shot is of the Bodiam Castle, East Sussex, England, built in the 14th century.

Castles continued

Not many castles are permanent homes to kings and generals, but frequently (to attract visitors) they are used as backdrops for battle re-enactments, military tattoos, jousting contests, falconry displays and the like. Such events are the perfect time to visit – as it enables you to capture pictures that show much more than the stonework alone.

Taste of Scotland

Kilts and bagpipes are synonymous with Scotland, so this piper makes a perfect foreground for a shot of Edinburgh Castle.

Sinister silhouette

Photographing castles in silhouette (or with infrared film) can provide an eerie feeling that often suits the subject matter well. Here the tortured willows in the foreground add to the atmosphere. Whilst this shot of Edinburgh castle does not show any pomp and ceremony, it does show the building's strategic position overlooking the whole of Scotland's capital.

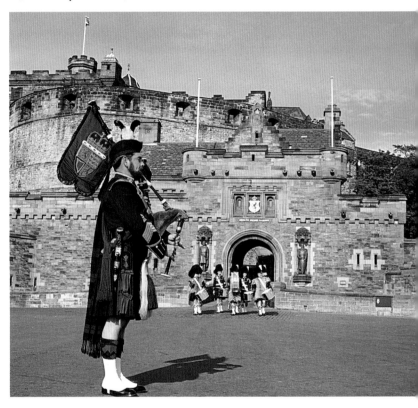

Dealing with display cases

What is the problem?
Many castles and stately homes are also museums, which display historical relics and curios related to the place's past. It is not unusual for these exhibits to be shown in glass display cases. But this makes photography difficult, as the camera tends to focus on the glass, you end up with reflections in your picture, and flash photography is a disaster.

Get right up close
The only way to avoid problems with reflections and focusing is to literally push the lens up to the surface of the glass casing.

Avoid flash
If at all possible don't use flash. Use high-speed film; black-and-white film with a rating or ISO 3200 is ideal, as this avoids any problems with colour balance.

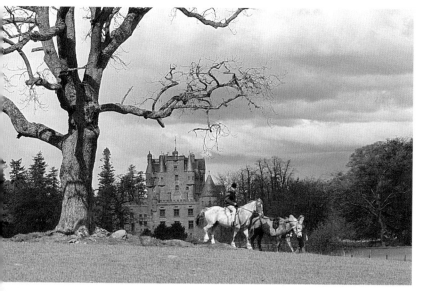

Differing approaches

These two shots of Glamis Castle in Scotland are very different – even though the composition and the viewpoint are practically identical. The horse riders seem to fit in well to the front-lit shot of this luxurious home (left). In the shot below the people and the castle have become more secondary, as the use of a multi-prism filter has created a semi-abstract composition.

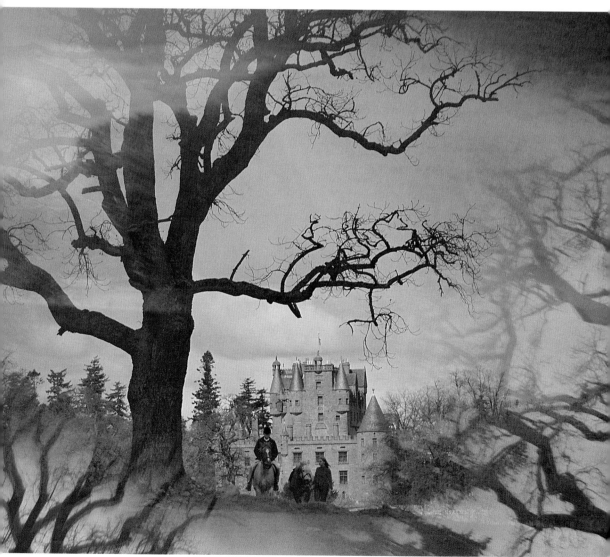

People and places

Local people are an important compositional element
to hunt out in your quest to photograph all the sights

Whilst you may try to avoid including other tourists in your holiday pictures, this does not mean that you should exclusively take pictures which are devoid of people. If you return home with pictures which feature buildings and landscapes alone you will have a very one-dimensional portfolio. Countries are defined by their people – by their appearance, their customs and their clothes. Including local inhabitants in your shots, therefore, will not just make your pictures more informative – if you choose your 'models' with care, the approach can turn good pictures into great ones.

The secret is to try and use local people as a compositional device. Keep a lookout for those that look particularly 'typical' or photogenic, and then find a way of incorporating them into the scene, so they act as either the foreground, or a scale object, for the landmark or landscape in the background.

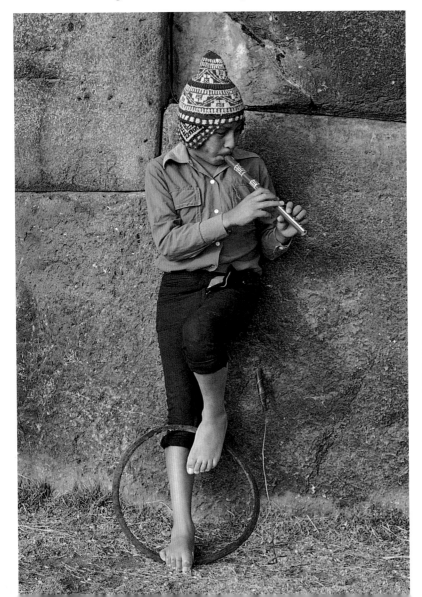

Cuzco, Peru

All four pictures on this spread were shot at an ancient Inca settlement just outside the city of Cuzco. Despite being a popular tourist destination, there are still locals in the area. On my visit I made sure that I arrived early in the morning, before most visitors arrived. This meant that anyone I saw at the site was almost certainly local.

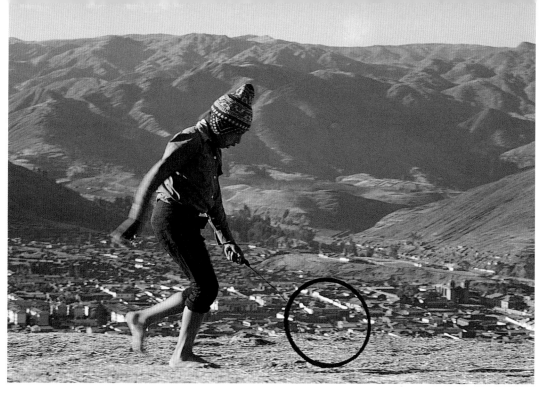

Waiting for the crowds

This boy in his typical Peruvian outfit was waiting for the tourists. Arriving early, I was able to photograph him alone relaxing before a day's work as a busker.

Sense of scale

These giant stones are so large, and fit so closely together, that it is hard to believe they were all moved without machines. The boy, practising his pipe, provides essential scale to the ancient wall.

Lucky break

It was by chance that I came across this herd of llamas grazing in the shadow of the Inca site – just as I was composing my shot, the animals' owner came on the scene, creating an even stronger composition.

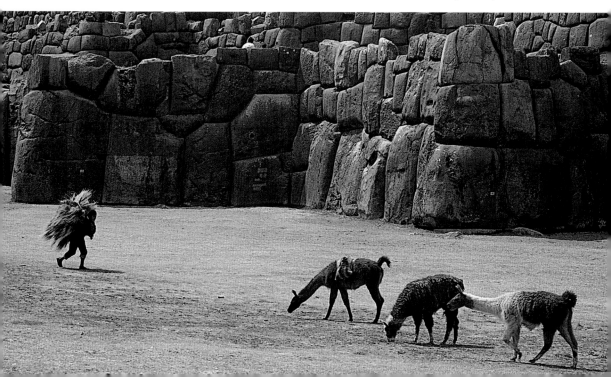

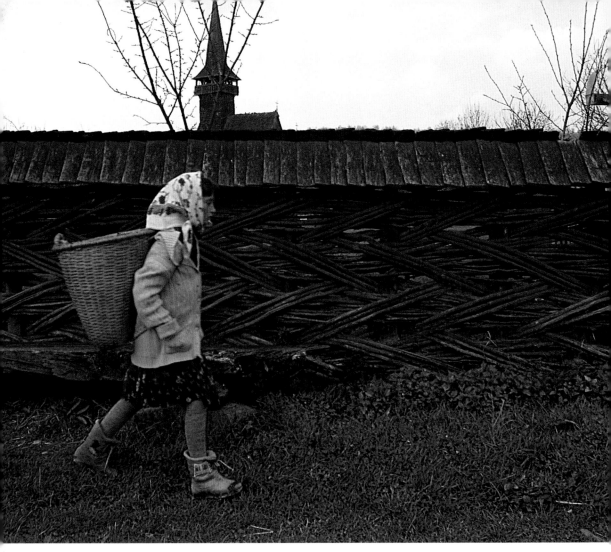

Rural life

A wide-angled approach allows you to capture the people that you meet on your travels, whilst showing the places where they live and work

IN SOME COUNTRIES that you visit the people do not just dress differently: their whole way of life is different. Everywhere you look, it may appear as if the place has been caught in a timewarp – with people carrying out tasks and living in a manner that have not been seen in your own homeland for decades. Sometimes, however, it is just poverty and destitution that you see. To record these things you need to adopt a documentary style of photography. ☛

Natural materials

Evan a simple picture can tell a lot about a culture. In the top image we see the reliance on local materials for manufacture in the woven basket, the woven fence, the wooden tiles, and the wooden church.

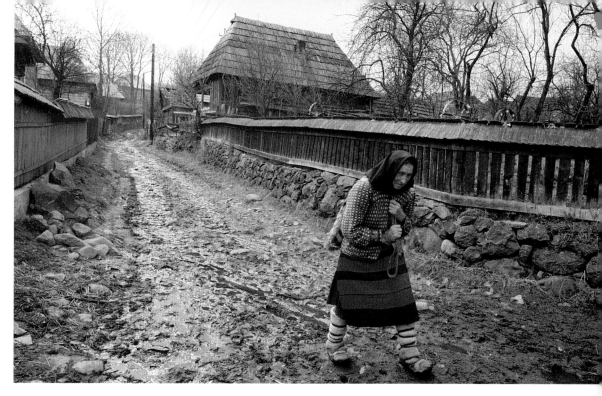

Country living

The pictures taken on these two pages, and the two overleaf, were all shot in Romania. This Eastern European country has only recently become easily accessible to tourists, and visiting its rural areas is like stepping back in time. The cart is the dominant form of transport (opposite, bottom), many streets are unsurfaced, and footwear is rudimentary (above). Such scenes will not last forever, one can feel obliged to photograph everything before it changes.

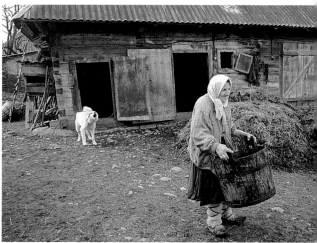

Working the land

The age at which people start and finish their working life also varies from country to country. This elderly farmer's wife was working very hard for long periods to make a living off the land.

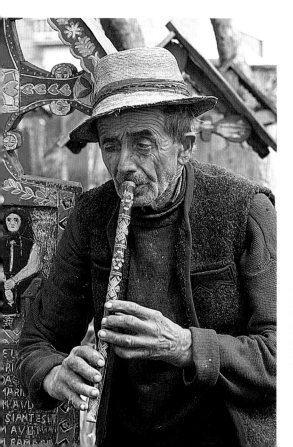

Detailed backdrop

An old man plays his handmade pipe – but this is not simply a portrait; the shot also clearly shows the Romanian obsession with wood carving.

Rural life continued

One of the key techniques of the documentary portrait is that rather than showing the person in isolation, he or she is seen within their surroundings. In this way you can see the place where the person lives or works – giving you a more detailed insight into who they are. With this sort of portrait, wide-angle lenses are the norm. The broad angle of view and excellent depth of field properties of this type of lens mean that you can keep the subject of the picture relatively large, whilst still including lots of background information.

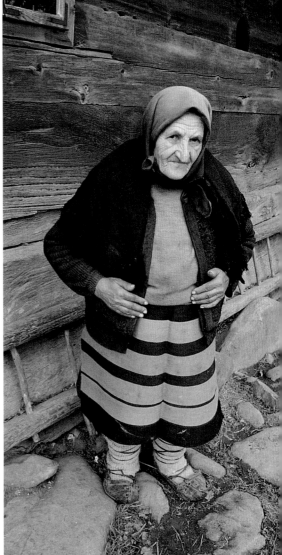

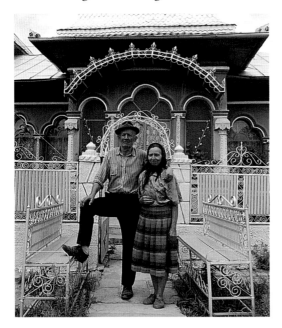

Willing subjects

In some countries farmers get understandably annoyed if you wander around their property whilst they are at work. In Romania, however, the people seemed very willing to oblige and to let them wander around their smallholdings. Most also agreed to pose for my 35mm wide-angle lens (above and right).

Signs of age

I was attracted by the expressive face of this old woman (left) – but rather than cropping in tight for a head-and-shoulders portrait, I framed the shot so as to show the typically Romanian clothes she was wearing. By keeping the camera at my eye level, the lens is looking down slightly at the woman – this accentuates her diminutive height.

Showing it all

It is not necessary to always crop in tightly when photographing people. Here a gateway creates an inner frame, whilst the surrounding detail shows us where the couple live.

Comical characters

Some typical scenes can look comical to those from a more industrialised country. But pigs have to get from farm to market somehow...

Strange sightings

Keep your eyes open and your camera ever prepared for unusual sights when you are away from home. In many countries, most things are taken to and from market on foot – so the obvious place for this goose to go was in the farmer's backpack!

Framing faces

When photographing head-and-shoulder portraits, it is usually a mistake to get too close or to shoot when the sun is shining

Flash tricks

Flash is almost essential after dark, but an added advantage is that because it lights up only the immediate foreground, backgrounds are hidden.

WHEN SHOOTING CLOSE-UPS of people's faces it is advisable to avoid using a wide-angle lens. Not only does it mean that you invade their personal space when you take the picture, the wide angle of view tends to exaggerate the prominence of their nose, eye sockets and chin. For more flattering shots, use a short telephoto lens – with a focal length of around 80–135mm. Longer lenses can be used if you want to shoot candid shots, or simply want to work from a more discreet distance.

You should also pay careful attention to the lighting if you want to show your subject at his or her best. If the illumination is too direct, then heavy shadows are likely to be cast under the features. Diffuse, or semi-diffuse, light is likely to give the most attractive results – and this may mean asking your subject to move out of the sun and into the shadows, to where the lighting is softer and more indirect. ☛

The bizarre and the eccentric

It is only natural to favour photographing the most interesting faces, the people with the most outrageous clothes, and those that fit a preconceived national stereotype. But this should only be a start to your portfolio of portraits. The shots on this page were all taken on the streets of Acapulco, Mexico.

Framing faces
continued

Changing shapes

I am fascinated by the shape of people's faces the world over. These shots taken during a visit to Mexico show some of the different regional characteristics that can be seen in the faces of its people.

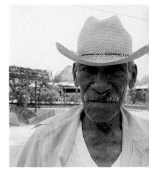

Perfect pose

Sometimes it is the setting that makes the portrait interesting. I couldn't resist taking this shot of the boy sitting with Ronald Macdonald!

Watch the backdrop

I deliberately found a plain background to accentuate the eye-catching shape of the boy's prize fish.

Visual attraction

Some colours attract the eye better in photos than others – even a splash of red clothing can dominate a portrait.

Synchro sun

Fill-in flash can give portraits a lift if the lighting is too dull.

Clues for composition

Cutting through limbs
Make sure the bottom of the frame does not cut through the neck, knees or other joints – as this looks unnatural. For a close-up, include some of the subject's shoulders in the frame.

Head space
When framing a face in the viewfinder, ensure there is a small gap between the top of the head and the top of the frame.

Looking space
If the person is looking sideways, frame the shot so there is more space in front of them than behind their heads.

Use hats and props
Hats are a great way of adding variety to a portrait – but they are also a good way of shading the features from intense sunlight. Additionally, they provide a way of isolating the face from the background – by creating a miniature frame around the head. An alternative is to use an umbrella or parasol.

Break the rules
The above points are for guidance only – you can ignore all of them and still get great shots.

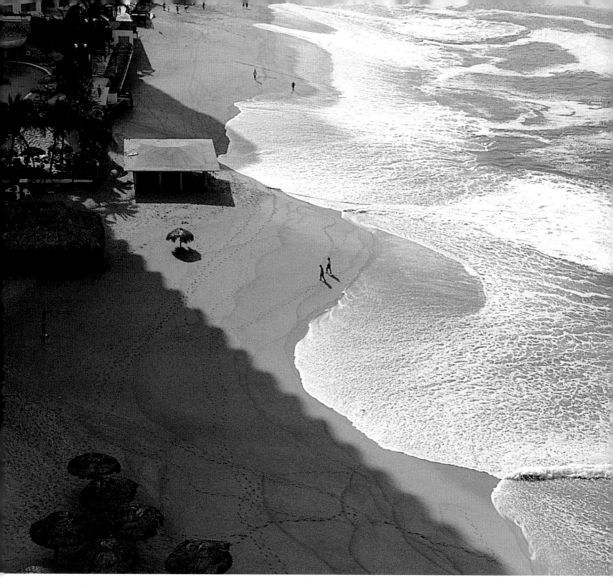

By the sea

The beach and blue seas are classic symbols of holidays. But these are not the easiest of locations for the photographer to work in...

Seaside resorts are capable of providing a huge variety of interesting subjects for the photographer. But local conditions mean that special care needs to be taken. The main obstacles are water and the sand – both of which can prove lethal to a camera. But if you take the necessary precautions, you can take pictures without fear of a huge repair bill. ☞

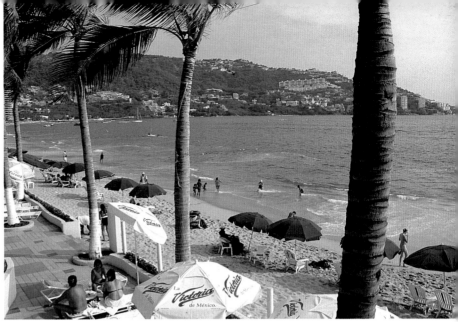

Along the seafront

Strong diagonals created by the sea's edge and the line of blue parasols lead the eye through this shot of the Acapulco seafront (above).

Sand patterns

An elevated view provides a very different perspective on a beach. The camera angle reveals the interesting scalloped shape created by the waves, which is repeated in the diagonal shadow (left).

Shades of pale

White-washed walls are typical of Mexican architecture, as they help to keep the interiors cool. High sidelighting ensures that the rounded form of this seaside building is accentuated, without the bright facade dazzling the viewer (left).

Exposure problems

Sand and water are good reflectors of light, and the intense highlights that result can sometimes mislead the camera's in-built meter. The solution is to increase exposure, or to meter from a small, representative area of the subject (right).

Making waves

Seaside resorts are dominated by brightly-coloured objects. Here a wave pool at a Mexican water park is awash with blobs of yellow, which creates an eye-grabbing pattern across the water's surface (above).

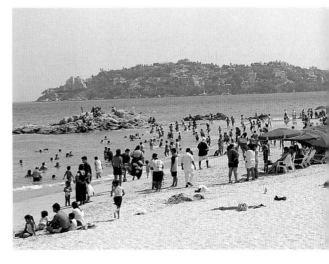

By the sea
continued

It is the sense of jollity that makes the seaside such a great place for taking pictures. From waterskiers to kids building sandcastles, you'll find that there are great pictures to be taken in every cove.

The beach is a particularly good place to take pictures of your children – as they are likely to look both relaxed and happy, amusing themselves along the shore. The sand also acts as a great reflector for close-ups, even providing fill-in for your shots – although partial cloud cover is helpful is you want to avoid screwed-up faces.

The sea itself can produce stunning scenes even out of the tourist season. The colour of the ocean can vary from turquoise to dark purple, reflecting and deepening the hue of the sky above. On a windless day, the surface is like a mirror to create peaceful scenes – but it can also become a fierce animal, with waves rising and crashing down to provide seascapes that are packed full of drama. The water also attracts its own picturesque subjects, such as brightly painted fishing boats.

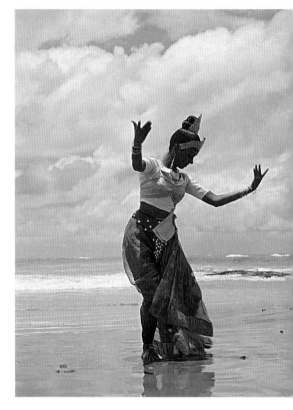

Lying on the sand
I lay down to get this interesting full-figure shot, taking the precaution of putting the camera in a plastic bag.

Perfect backdrop
A seascape provides an idyllic backdrop for all sorts of portraits – as in this shot of a traditional Thai dancer.

A child's playground

Beaches are places where children are really allowed to act like children. They can make a mess (above), or they can be absorbed in what they are doing for hours on end (below) – these occasions are perfect times to get your child looking natural on film.

Camera protection

Check the small print
Damage to cameras caused by water or sand will probably not be covered by either the manufacturer's guarantee, or by your insurance policy. As salt water can mean instantaneous and irrevocable damage to photographic gear it pays to take your own precautions.

Ready for action
Slight sea spray or the odd grain of sand is unlikely to do any real damage. Take a towel or flannel to wipe splashes off immediately. Use a brush to remove sand (see p.154).

Simple solutions
A plastic bag gives basic protection against water splashes (and heavy rain) – shoot through the plastic (rather than making a hole), and press the shutter from the outside of the bag.

Better protection
A wide range of cameras is available giving varying protection against water. These are available to suit all budgets – from single-use disposable cameras to top-end deep-sea diving gear – and are worth buying as an extra camera for a beach holiday (see p.10).

Strange sightings

People get up to the strangest things, and wear the most bizarre things when they are by the coast. I couldn't resist taking a picture of this child in his parasol-hat (left). These performers, on the other hand, looked out of place by the side of the sea (right) – even though the soft sand was actually the ideal place for them to practise their act.

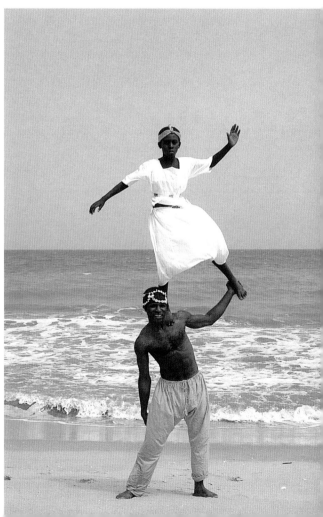

Sport

Focusing the lens even before the subject enters the viewfinder is often a sensible plan when photographing fast-moving subjects

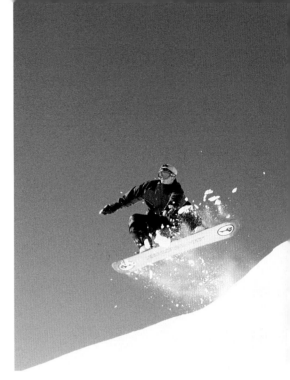

OCUSING REQUIRES SPECIAL attention when photographing sports. Whilst you can freeze movement with fast shutter speeds (see p.14), if the lens is not focused at the right point the shot will still not be sharp. As you frequently need to use long telephotos which provide restricted depth of field, and as a moving target means the subject distance keeps changing, it ends up being difficult to adjust the lens fast enough to ensure a pinsharp shot.

Some autofocus SLRs have a 'predictive autofocus' mode that can not only track moving subjects accurately, but calculate where they will have moved to during the time it takes between firing the shutter and the exposure actually being taken. For those without the benefit of this technology, the old-fashioned solution is to use a technique called 'prefocusing'. In most sports you can anticipate the route the competitors will take. If you focus on a point along this path, you can then wait for subject to enter the viewfinder and then fire – knowing the focus is already perfectly adjusted.

Setting a trap

Rather than focusing on this snowboarder, I focused on the mound before he jumped then fired the shutter when he was in midair.

Keep it loose

Don't always try and fill the frame. The young soccer player (below) has become little more than the foreground for the seascape behind.

How to pan

What is it?
Panning is a technique where the camera moves whilst the shot is being taken – following a moving subject. This allows you to use a slightly slower shutter speed than would normally be needed for both the lens and subject – and it provides a relatively sharp subject against a beautifully blurred backdrop.

How to do it
Prefocus on the point where the shot will be taken. Following the subject smoothly in the viewfinder through a 90° arc, twisting from the hips. Fire in the middle of the arc, using a shutter speed between 1/15sec and 1/125sec. Keep trying – this technique needs practise!

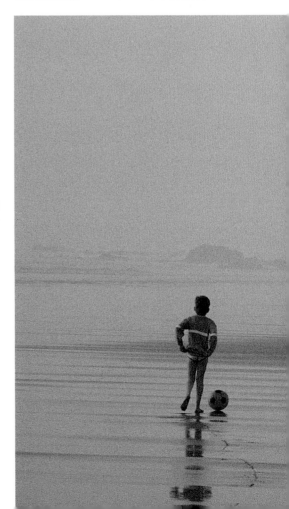

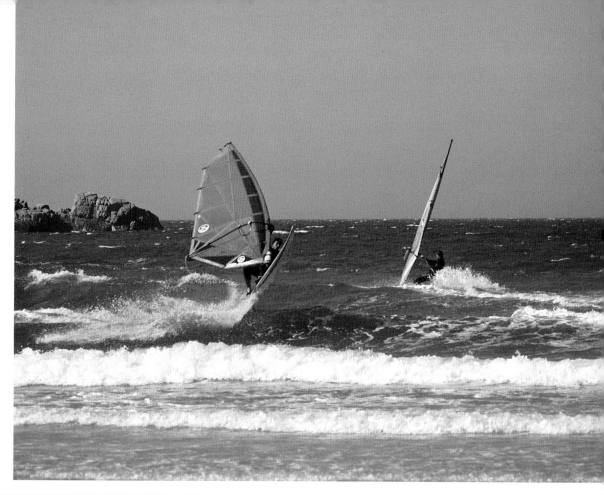

Directions

It is much easier to focus on a subject when it is moving across the frame (above), rather than towards you (right), as the focused distance does not keep changing.

Again and again

With many sports, prefocusing will let you take shots of each competitor as they pass.

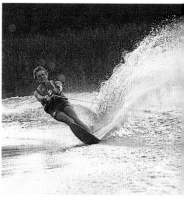

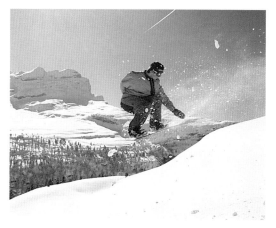

Wildlife

The natural timidity and camouflage of most animals and birds mean they are not an easy target for the photographer – even if you have a long lens available

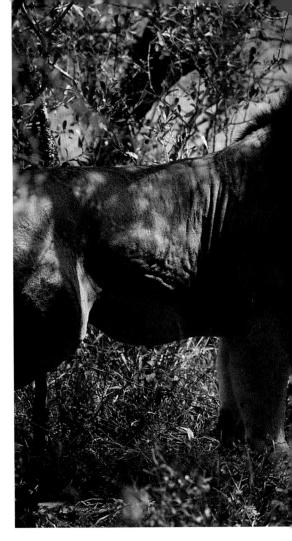

PHOTOGRAPHING ANIMALS AND birds frequently requires great patience. Most species keep their distance from man, and unless you have the time you often require luck, local knowledge and a long lens to capture wildlife in the wild.

For most holidaymakers, the animals they are most likely to shoot are going to be found in a park, zoo or wildlife sanctuary. These provide great accessibility – but still you will need a good telephoto lens setting for decent close-ups.

One problem commonly faced at zoos is cages and wire fences. The best way to avoid these appearing in a shot is to push the lens up as close to the fence as possible, and then use the widest aperture available.

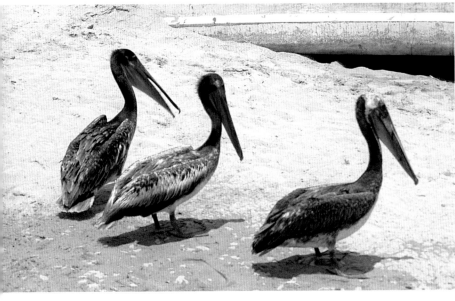

Brown pelicans, Acapulco

Some species, of course, show little fear of humans. Pelicans, for instance, can end up relying on scraps from the fishermen.

Flamingoes, Yucatan, Mexico

Focusing on and tracking individual birds in flight takes a lot of practice. Here the sheer number of flamingoes made the task that much easier.

Smaller prey

For reptiles and insects, a long lens may not be necessary. But if you want to fill the frame with your subject, you may well need specialist close-up equipment (see page 78). This shot of a tree frog (right) was taken in Mexico with a 100mm macro lens.

On safari

In African game reserves, you rely on the knowledge of your guide, and the relatively safe vantage point of your vehicle, to get within a sensible shooting distance of wildlife. The lion (right) was taken in Kruger National Park, South Africa with a Pentax SLR and a 300mm lens.

Using teleconverters

The ideal focal length

The focal length you need for wildlife varies with subject size, and how close you can get to it. A 300mm lens is a good starting point.

Doubling your firepower

Teleconverters are an affordable, lightweight accessory that increase the focal length of a lens. On an SLR, they fit between your lens and camera. They are also available for some compacts and digital cameras, but screw into the front of the lens. They come in different magnifications – a 2.0x converter doubles the maximum focal length of the lens used.

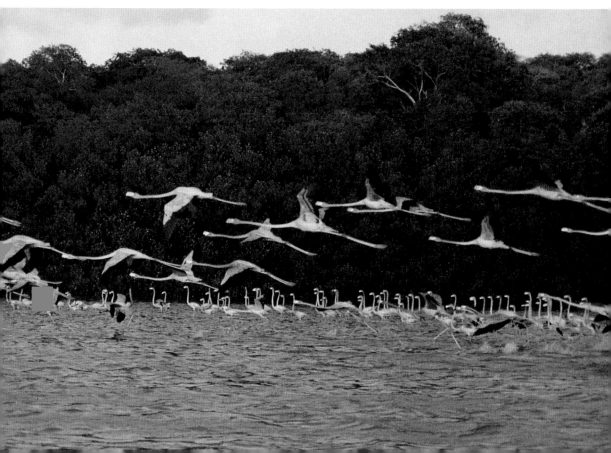

Art trails

Following in the footsteps of the famous can add a
biographical and educational tone to your holiday pictures

EVERY COUNTRY OR CITY has its famous historical residents. Whether a writer, politician or musician, it can be interesting to follow in their footsteps whilst on holiday – visiting and recording the places that they lived in and went to. Whether it is William Shakespeare or Elvis Presley that you are interested in, you learn much more about a person by visiting their old haunts. Many of these places will be open to the public, if the person is particularly famous in that country, and there may even be organised tours. Painters, sculptors and architects are particularly profitable for such a photographic portfolio – as you can include pictures of the person's work.

Constantin Brancusi, 1876–1957

Brancusi is probably Romania's best-known artist – with his sculpture being found in many of the world's most prestigious museums. These shots show his living room, front door and well in Romania. They not only show his humble roots as a carpenter, they also show the Romanian obsession with carving and the country's reliance on wood as a building material.

Table of Silence, Tirgu Jiu

This symbolic table and twelve chairs were sculpted by Brancusi for a memorial park in honour of those who died in the First World War. The elevated camera position allows you to see the symmetry more clearly than a ground-level viewpoint would have done.

Miniature masterpieces

Some of Brancusi's best-known works are small: the statue of The Kiss (below) is just 28cm high. When a subject is a light colour (or dark colour as with the bronze above), it is sensible to take shots at different readings to ensure you have got the right exposure.

Emphasising form

For these imposing Brancusi sculptures, I stood so the late afternoon sunlight was to the side of me. This lighting angle shows the three-dimensional shapes of the structures well. Tirgu Jiu, Romania.

Abstract images

One of the skills of a successful photographer is to be able to make interesting pictures even when in the least photogenic locations

O NE OF THE MOST pleasurable aspects of photography is finding pictures where at first sight there are none. The secret is to look at the scene not as a pictorial composition – but simply to look out for pleasing shapes and colour combinations, seeing the world in abstract forms, rather than as things. The beauty is that once you start developing an eye for this type of picture, you start to see them wherever you go. It doesn't matter if you are not visiting a picture-postcard village and don't have photogenic views – these shots can be found in the least-promising locations. ☛

Seeing the shot

Rather than show a straight picture of this sculpture, I wanted to use it simply as part of the series of patterns already created by the pathway and the steps. Rabat, Morocco.

Riley's Toffee

I spotted this eye-catching window display (right) in a shop outside Toronto. I deliberately included the shop blind and the reflection of the sky, to make the composition slightly more abstract.

Look to the skies

Cloudscapes often make interesting photographs – but by including a strong foreground shape (left) the patterns and colour of the sky somehow become more powerful. Shot in Portugal.

Big Brother

An attention-grabbing sign for an optician's – spotted in Paris.

Patterns in a pool

The converging lines of a swimming pool found in the Gambia create a powerful pattern that the eye finds hard to resist.

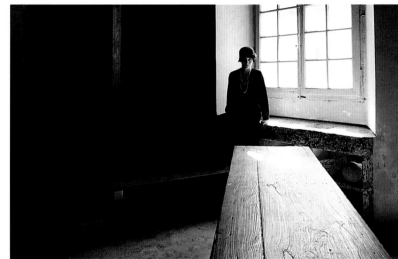

Guest house, Bucharest

Rather than walls and furniture, it is possible to see the picture above as an elaborate collection of different shapes, from the oblongs on the wall to the circles on the cupboard, the lozenges on the ceiling, and so on.

Light and dark

Shot in a French castle, it is the path of light created by the table top that leads the eye through this picture.

Repeated shapes

Any group of identical objects creates pattern. The tables below were piled up outside a door in northern France.

Abstract images
continued

Coastal Road, near Tangier
This shot is about tone and diagonal lines – the actual subject matter is completely unimportant.

A question of scale
A giant abstract mural on the side of a New York building (above) creates an impressive backdrop – but the inclusion of the solitary striding figure is necessary to make the shot come alive.

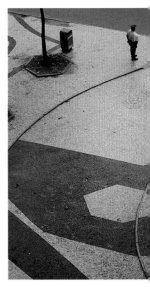

Sea and sky
It is the colour of the sky and the sea that really makes this picture, but the monolith in the foreground is essential to give the shot focus. Rio de Janeiro, Brazil.

Looking down
High viewpoints frequently reveal patterns which cannot be seen clearly at ground level – as in this Brazilian street scene (right).

Attractive colours
The strong combinations of hues can make eye-catching pictures even in the dullest of lights – as in this shot of an ice-cream stall in Scarborough, England.

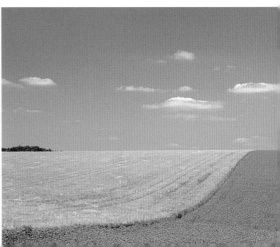

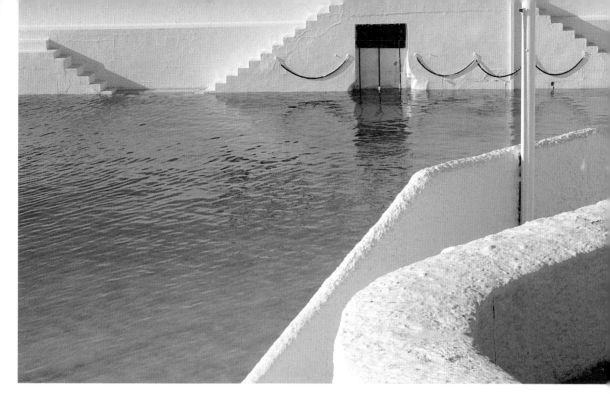

Lines of the lido

Late afternoon sunlight helps bring out the texture of the white walls of an outdoor swimming pool in Penzance, Cornwall.

Middle of nowhere

Deserts, by their nature, rarely offer much variety in photographic subject matter. This advertising sign with its powerful shape therefore seemed incongruous in the arid Peruvian landscape.

Crop rotation

The patterns and colours of fields always provide great pictures for the abstract photographer. Look out for particularly impressive colours – such as the yellow of oilseed rape, or the blue flowers of linseed.

Work of art

A fairground ride by the side of a beach (right) appears like a modern sculpture when seen deserted, and isolated against a cloudy sky.

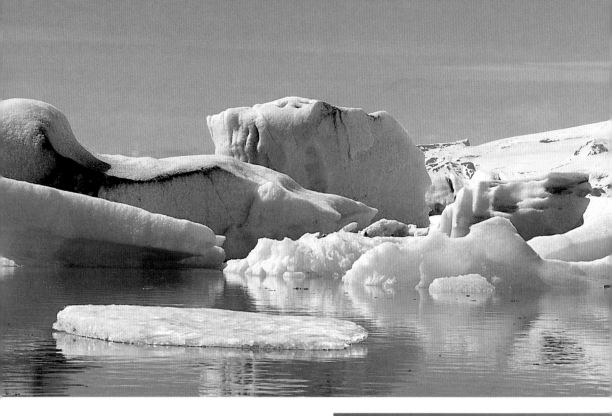

Snow and ice

Bright white landscapes, created by snow or mist, cause exposure problems which can be overcome only by taking control yourself

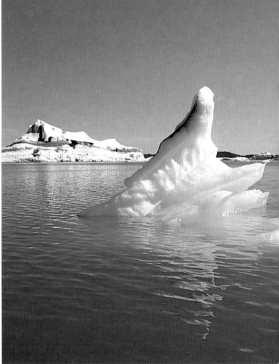

True blue

For these shots of icebergs off Iceland I ensured that the snow appeared white by overexposing each shot by a full stop – setting exposure compensation dial on my SLR to +1. I also used a polariser to reduce reflections from the water. However, I did not turn the filter to get the maximum effect, as otherwise the colour of the sky would have been too deep.

AUTOMATIC EXPOSURE SYSTEMS are extremely good at setting shutter speed, aperture, or both, in all manner of lighting conditions. But they are not foolproof, and in snowy conditions they are more likely to get it wrong. Snow can envelop everything, creating a scene which is predominantly white in tone. The meter tries to compensate for the brightness by reducing exposure, and you end up with snow that looks a muddy brown or blue.

Usually you need to take manual control, forcing the camera to give the scene more exposure. The amount of compensation needed depends on how much snow there is in the shot, and the sun's brightness. A wide-angle all-white landscape may require two more stops exposure than the meter suggests; a close-up portrait may need no correction at all.

Cameras in the cold

Go slow
Batteries can become sluggish in sub-zero conditions, even if they are fresh. They fail quicker the colder it gets, creating particular problems in Arctic regions or on ski slopes.

Keeping things running
Keep the battery warm, by carrying the camera inside your coat, close to your body, until you are ready to take the picture.

Emergency power
Take plenty of spare fresh batteries with you on your trip, and keep one warm in your pocket for when it is needed. Seemingly dead batteries will usually come back to life once they reach normal temperatures – so don't be in a hurry to throw them away.

Film handling
Film is more brittle in the cold, so needs to be wound on slowly if you do not have motorised film transport on your camera.

Battling against the elements

These Icelandic men are moving icebergs out of the shipping channels, so that bigger boats can enter the port more easily. The high viewpoint helps to stress what the men are up against.

Blue Lagoon, Iceland

The warm waste water from a chemical plant is bathed in by visitors in the belief that the substances it contain will cure them of all kinds of ills.

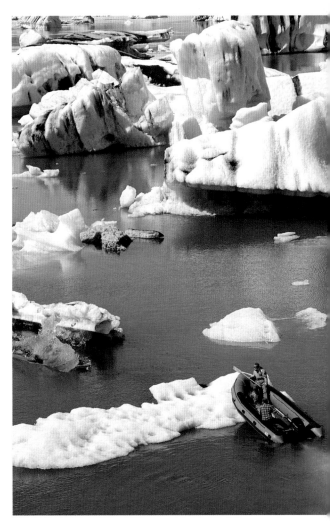

Inclement weather

It might not be as rewarding as when the sun shines, but it is still possible to shoot good pictures in rain, fog and storm

RAIN IS NOT WELCOMED by holiday-makers. Most travel to find the sun – or to spend their days outdoors. For the photographer, poor weather conditions can be particularly galling – as although you can still happily visit places on a grey day, it seriously limits the type of pictures that you can take when you are there. However, it is wrong to take the view that if it is raining you should leave your camera in the car, or back in the holiday apartment. It is possible to take some pictures even in the most atrocious conditions – as the ones on these pages endeavour to prove.

Lighting can be dramatic in a downpour – even if it is not particularly bright, and this can be especially useful for creating dramatic landscapes. The rain also creates puddles that not only create reflections, but that bounce light back onto buildings creating a soft, even illumination that is very suitable for some architectural shots. Even in the worst conditions, the resulting low contrast can help create pictures with their own eerie, individual character.

Snow storm

The low-contrast scene shows little detail – but it still provides an evocative portrayal of two youngsters heading off into the snow.

Misty morning

An early morning shot of Fountains Abbey in Yorkshire (left). The mist might obscure the subject, but it creates an atmosphere that suits the famous ruins well.

Foggy afternoon in Amsterdam

Fog changes the way things look as it separates the planes – things that are slightly more distant are less distinct, and everything on the horizon is hidden. Much of the scene is merged into a similar tone, making anything else stand out.

Bouncing light

The wet surfaces of the New York roads (right), not only bounce diffuse sunlight back onto the buildings, but also reflect the lights of the passing traffic.

Rolling clouds, Austria

Summer storms are particularly profitable for the landscape photographer, because the lighting changes so quickly. The added bonus is that when the clouds lift, the rain has washed the dust and smog from the sky, so that you can see for miles.

Sunsets

Spectacular shots of the setting sun are near the top of the wish lists of most holidaying photographers

CONTRARY TO POPULAR opinion, the sun does not always set in the west. Depending on the time of year, and the latitude, it can fall behind the horizon at any point between northwest and southwest. This will need checking out if you want to frame a particular scene at sunset. Furthermore, the nearer you are to the equator the shorter the time a sunset will last – so you may need to act quicky.

If particularly spectacular, you can get away with framing the sunset alone in your shot. But normally it will be more powerful if you can add foreground interest. The classic compositional device is a silhouette – of a house, tree or person. To ensure that you get rich colours, you should meter for exposure from the sky alone, without the subject in the frame.

To increase the expanse of colour within the scene, include water in your picture; this will not only reflect the sky, but may create a path of light that leads the eye through to the horizon.

Digital colour correction

For those using film cameras, the easiest way in which to intensify the colour of a sunset is by adding a filter. But with some digital cameras, no extra equipment is necessary. Digital cameras have an automatic white balance system, which electronically adjusts the overall colour of a scene to suit the type of lighting that is being used (so indoor bulb lighting doesn't create orange pictures, for example). With sunsets, the white balance system can tend to try to filter out those red and yellow hues from the sky, so that results look disappointing. To get more realistic shots you should switch to manual white balance, and use the preset level for daylight. Alternatively, with some cameras, you can set the white balance to create even stronger colours; rather than pointing the camera at a white card to set the colour balance, point it at something blue. The colours will then be more orange in tone.

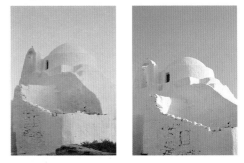

Changing the balance

A small change in colour balance can make a shot appear as it were taken at a different time of day. The shot on the left was, in fact, taken at the same time as the one on the right.

Tent at twilight

Here's a straightforward trick shot to try when camping. The tent (above) looks rather drab in a straight shot. But with a powerful video light, or remote flash, inside the tent, the sunset scene comes alive (right).

Golden reflections

It is not just the sun and sky that appear orange at dusk – it can give a warm glow to anything that catches the light, as in the shot above.

Drawing the eye

The sea provides a perfect foreground for sunsets (below). Highlights on the water create a path through the composition.

Dark shapes

A strong recognisable silhouette creates the classic foreground for a sunset shot. Mykonos, Greece.

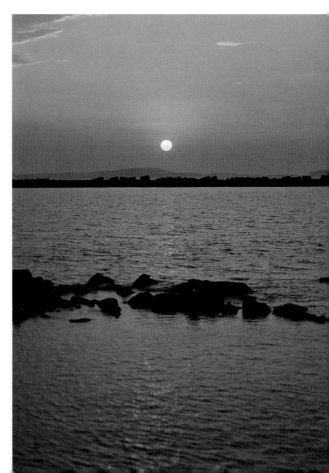

Blobs of colour

Streetlamps, tail lights and floodlit buildings create bright-coloured highlights that complement a sunset.

Night lights

Just because the sun has set, it does not mean that you have to put your camera away for the day. And there's no need for flash or fast film either...

NIGHT CAN BE ONE OF the most rewarding times to photograph a city. Much of the mess is hidden in darkness, whilst the key buildings are illuminated by floodlights. Further colour and bright patterns are added by the traffic, as it traces its way through the streets.

The best time for taking long-exposure shots at night is not when it is pitch black. Instead try and take your shots soon after sunset, as this will mean that there is still some colour in the sky.

Rather than using fast film, try and use normal film, as this will provide the long exposures to blur traffic. A tripod is recommended for such slow shutter speeds, but there are alternatives for those who want to carry as little as possible (see box opposite).

Start early

Don't wait too long before taking night shots. Start looking for shots just after dusk, as this means there is some colour in the sky, as in this New York scene.

Double exposure

The famous Blackpool illuminations create twice as much colour when framed so that they reflect in the sea. Shot at 1/8sec at f/8 with ISO 100 film.

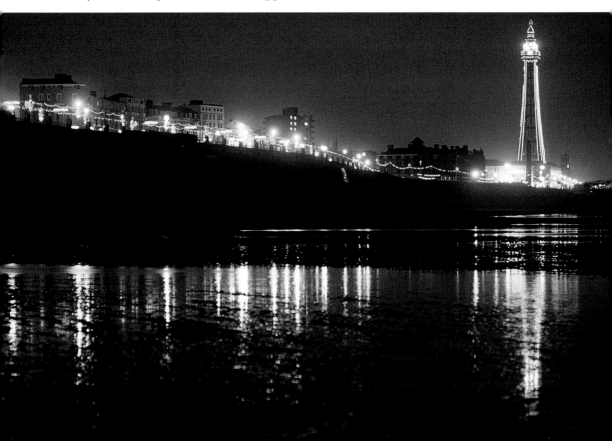

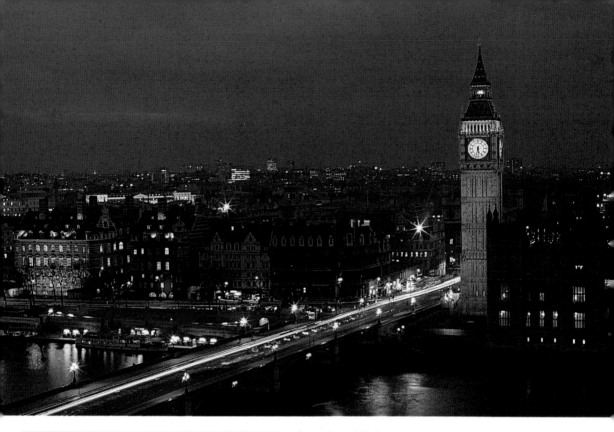

Impromptu camera supports

What, no tripod?
When travelling you will often find yourself in situations where you need to use a much longer exposure than you can possibly manage handheld, but don't have a tripod with you.

Get stable
Find a table, car roof or window ledge where you can place the camera and it is stable and safe. Prop the camera up with a towel, or whatever you have handy, to frame the shot as you want it. Fire the camera using the self-timer, as this will minimise vibration.

Streaks of light
To turn moving traffic at night into streaks of white and red light, you should aim to set an exposure of at least 20 seconds. With some cameras, you will need to do this with the B (or bulb) setting. This keeps the shutter open for as long as you have your finger on the trigger. To avoid vibrations when doing this, a cable release should be used.

Calculating exposure
For night shots, a range of different exposures will often give acceptable results; only the brightness of the lights differs. If you use a long enough exposure, night becomes dusk, as in this shot of Salzburg.

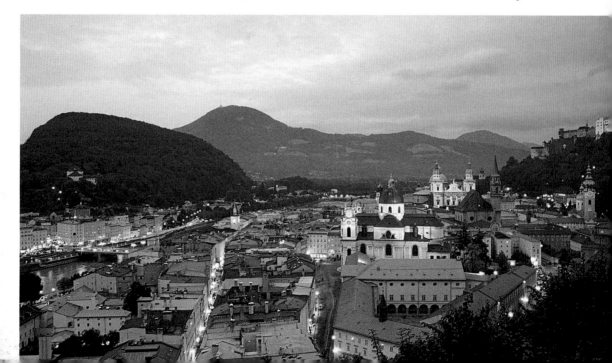

Chapter 4
On location

Assignment 1

Chichén Itzá, Mexico

The trouble with the most photogenic places in the world is that they attract millions of visitors a year. Getting crowd-free pictures, therefore, is never easy. In these assignments, I show that you can get great pictures in the best-known tourist attractions around the globe despite the hordes of tourists. My first tip is to get to the busiest sites early – before the gates open, even. You can then be the first in, and can take as many shots as possible before the coach parties arrive for the day.

High viewpoint

Places that give you a bird's-eye view of a site can be left to later in the day, as any people in the picture will tend to look like ants, and therefore are unlikely to interfere with the composition.

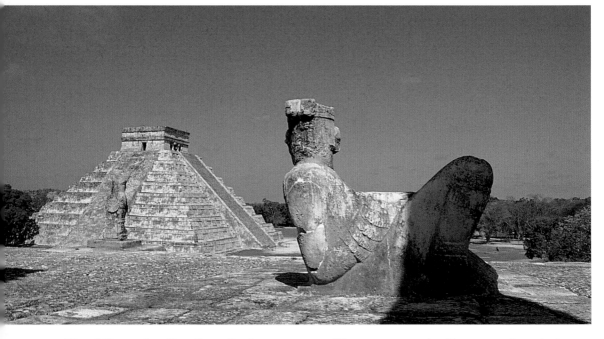

Shoot the main attractions first

Every tourist attraction has its main focal point – the subject, or view, that is seen in every postcard and brochure. But this will also be the place where the crowds congregate. At Chichén Itzá, it is the pyramid, or El Castillo, that is the focal point. This was therefore the first thing I photographed on arrival.

The more remote, the more deserted

This shot of the Temple of the Warriors and the overseeing statue of Chac-Mool necessitated climbing a lot of stone stairs. Such a location is unlikely to swarm with tourists, and it was therefore a shot that I left to later in the day – allowing me to concentrate on ground-level subjects until the site became busy.

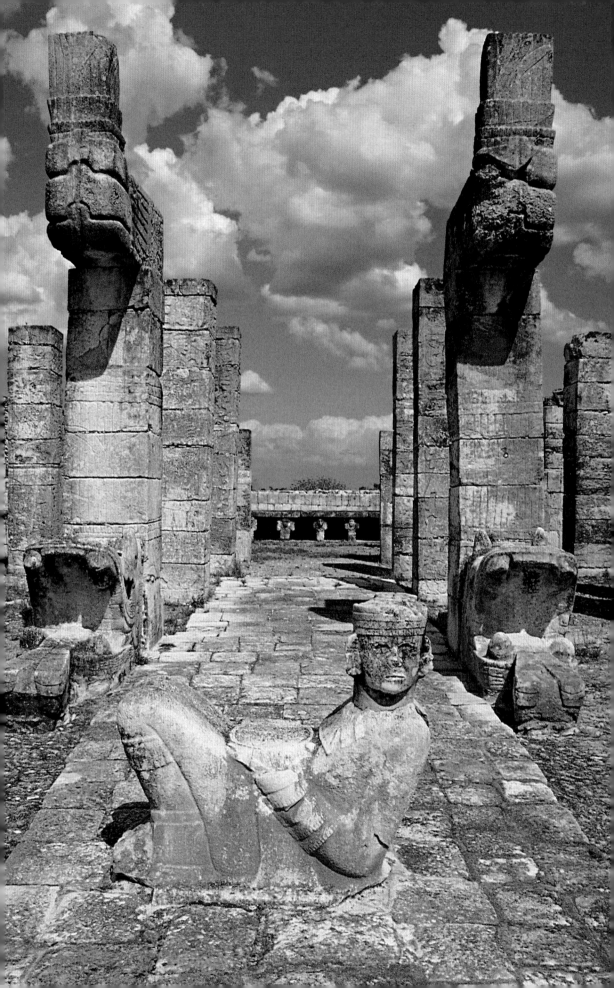

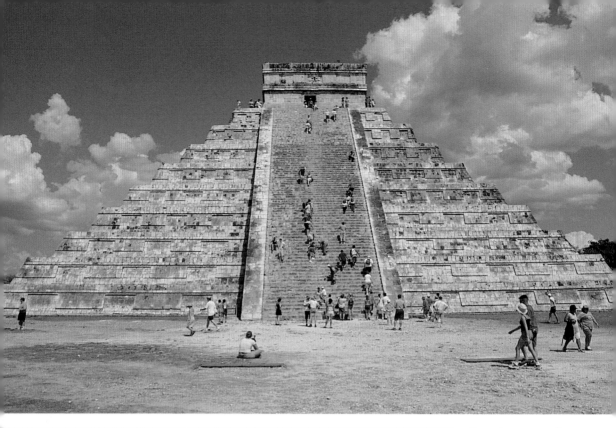

People everywhere

Built by the Mayan civilisation some 1500 years ago, Chichén Itzá is probably the most-visited historic site in Mexico. The Pyramid of Kukukán, or El Castillo, is just one of the attractions of this ancient city – but is the one that everyone around the globe recognises. Soon it swarms with people — and although they add a sense of scale to the shot, it is still worth making an early start to get a selection of shots with no one in sight.

A wider view

This shot shows the same subject as the picture on the previous page, but here the Temple of the Warriors is shown in its entirety. Although there is virtually no one at the top of the structure (where I took the other shot), it is impossible to get a general view without fellow visitors appearing in shot.

Watching the people

Most of the time you avoid including people in your architectural shots whenever possible. But sometimes it is the tourists themselves that make the shot. I couldn't help be amused by the sight of a group of nuns using umbrellas as sun shades!

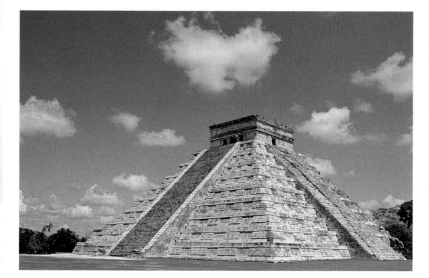

Worth the effort

It is a shot like this which makes it worth the effort of getting to your location as early as possible in the morning. It might mean avoiding the organised tours, and forgetting about breakfast and lie-ins, but it is the only way that you are likely to get the place practically to yourself for a few minutes.

Shooting at high noon

Few subjects look at their best in midday sun. An exception is stone carvings. Lit from above, the shadows create the best relief between the different levels, revealing the patterns or writing more clearly.

Leaving the detail until later

People cannot usually get in your way when you use a telephoto lens to capture architectural details. Even if they do, it is easy to wait until they move on to the next spot on the tourist trail. Such shots can be left until later in the day.

Tackling humidity

The problem
Condensation gathers on the lens, viewfinder and mirror of your camera – preventing you from seeing what you are shooting. If you do try and take shots, you end up with foggy pictures .

Why it happens
It happens when the camera is moved from a cool place to a hot one (or sometimes the other way round). It is a particular problem in hot, humid countries – especially if the hotels, shops and restaurants are air-conditioned. Every time you go out, your camera mists up. Other trouble spots include taking your camera into glasshouses, or when leaving cold cave complexes.

What is the solution?
Your camera needs time to acclimatise – once it reaches the temperature of your surroundings, the problem disappears. Leave the air-conditioned room an hour or so before you take your pictures – taking the camera out of your bag as soon as you are outdoors. Or leave the camera on a balcony as you get ready.

Extreme measures
Persistent high humidity, in tropical rainforest for instance, may mean that water will penetrate deep into the camera causing damage. Seal equipment in plastic bags with desiccating silica gel. The gel can be periodically dried out for re-use.

Assignment 2
Barcelona

When visiting a city or attraction for a short period of time it is impossible to discover all the best views for yourself. This is why research is so important. By looking at the guide books and trawling the internet you can get a good idea of what you want to photograph even before you leave home. Don't give up with the research when you arrive at your destination – postcards are a superb source of inspiration, showing you viewpoints that you can then copy.

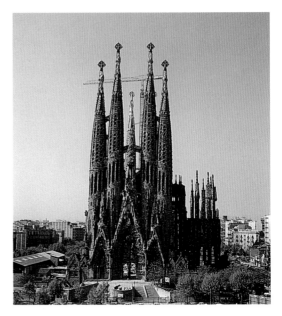

Classic shot

The Sagrada Familia is the most famous building in Barcelona. A distant view gives an undistorted view of the cathedral, whilst the inclusion of the crane shows the 100-year-old landmark is yet to be completed!

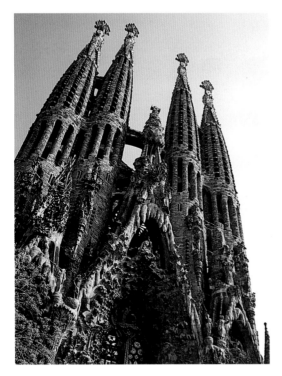

Angled approach

A wide-angle lens tilted upwards near the base of the Sagrada Familia gives a slanted composition which seems to complement the modernist architecture of Gaudi. The angle of view also has the added bonus that the crane is no longer visible.

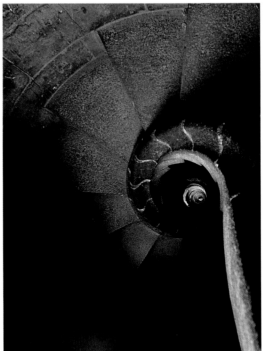

Vertigo

A very different view of the Barcelona cathedral from the other two on this page. This is taken on the inside of one of the elaborate towers. The snaking shape of the spiral staircase is accentuated by pointing the camera straight down.

Harsh treatment

These colourful mosaics and ornate architectural features are some of the many photogenic delights to be found at Güell Park in Barcelona – another of Antonio Gaudi's famous designs. Here the harsh sunlight creates a high contrast between shadows and highlights – as well as strong colours. Although the lighting would not suit all subjects, it appears to suit the modernist design of the subject matter.

Studying the subject

The more research you do on the place you are visiting, whilst you are there or before you leave, the more you will be able to concentrate your available time on taking your picture. These two shots are of interiors designed by Gaudi, which I wouldn't have discovered if I had not spent time hunting out the architect's many works in Barcelona.

Interior designs

When shooting interiors, try and use existing light, rather than using flash. On holiday, you will not have the time or the equipment to set up sophisticated lighting – and a single flashgun will undoubtedly just kill the atmosphere of the room. It's better to use window light and to accept that some parts of the shot will be dark and others bright. Find a way of supporting or bracing the camera to allow a long enough shutter speed – or switch to a faster film.

Putting on a facade

Gaudi remodelled the exterior of La Casa Battló, rather than the building itself. I spotted the possibility of this close-up from a more general shot I had seen in a guide book, with the main balcony of the apartment block looking like a giant mouth.

On a mission

This is the grand entrance to one of Gaudi's lesser-known buildings – the College of the Teresians. However, once you find yourself getting into a subject, and exploring a location with purpose, you begin photographing all sorts of things that you may well not have otherwise noticed or discovered.

Things to check with the embassy

Visa

Whether you require visas, and whether you need to get these in advance, will depend on your destination, nationality and on the purpose of your visit. If you travel as a photographer, rather than a tourist, different rules may apply.

Customs

For some destinations there are restrictions on how much film you can take in, or on the value of your equipment. You may need to have a 'carnet' to prove you take out what you brought in – and may even need to pay a deposit which is held until you leave. In other countries it can be helpful to have copies of receipts for your gear, so you can prove where you bought it, and that tax and duty have been paid.

Assignment 3
Stonehenge

Some of the places that you visit on holiday will have more photographic potential than others. When you find a subject that inspires you, don't be content with a fleeting tour. Be prepared to spend the whole day there, to use different lighting; if possible, try going back on different days. You might not be in the area for very long, but it is important to maximise the time that you do have. Invest film, as well as time, on worthwhile subjects. Film may not be cheap, but compared with the cost of many vacations it is a small price to pay in the pursuit of great pictures.

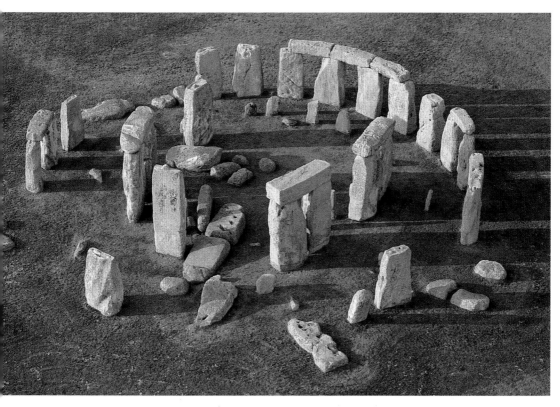

View from the air

At many famous places it is possible to find airfields that offer short sightseeing flights in helicopters or small planes. In some locations balloon flights are even offered. All these offer unique views for the photographer – particularly if the weather is favourable. Stonehenge, for instance, is near a main road, and is surrounded by fences, car parks and a visitor centre – the shots you can take are therefore limited. An aerial view allows you to cut all of these things out, showing the site as it might have appeared centuries ago.

Waiting for the light to break

The main advantage of returning to a site, or staying there for more than a few hours, is that you are able to photograph it in different lighting conditions. This shot (left) was taken after a long wait during which the sun remained behind the clouds; the moment it broke through, the stones immediately came alive within the viewfinder – and it was then important to act quickly in case the conditions did not last.

Up close and in detail

Stonehenge is such a well-known site, that it is difficult to come away with a picture that is different. This close-up of the pieces of stone, however, caught my eye. The cave-like hole creates a feeling of depth, but the real attraction of the shot is that the lichen adds an elaborate natural pattern.

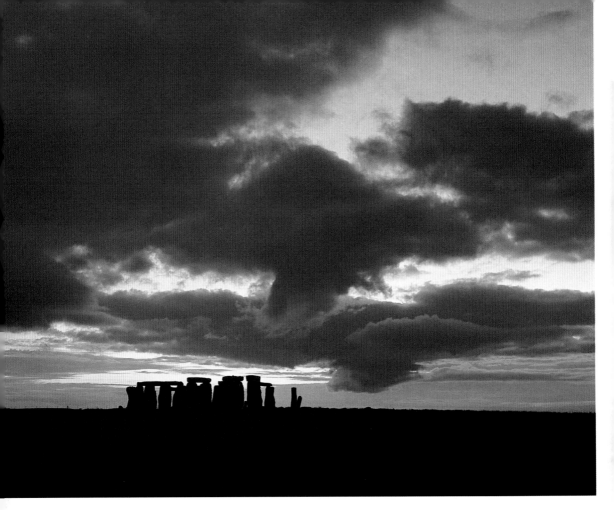

Poor conditions

An overcast day might limit the picture possibilities, but the grey colours and dark skies can create moody shots (left). An alternative in these conditions would be to switch to black-and-white film.

Cloud cover

Late in the day, the site was closed, but it is still possible to shoot from a distance. This time my patience was rewarded by a dramatic sky. I made the most of this, allowing the cloudscape to dominate the shot.

Different seasons

Some sites you may end up visiting in different years, and different seasons. Snow is always particularly good at showing places in a new light – the thick white blankets all foreground detail, whilst bouncing light back into the shadow areas.

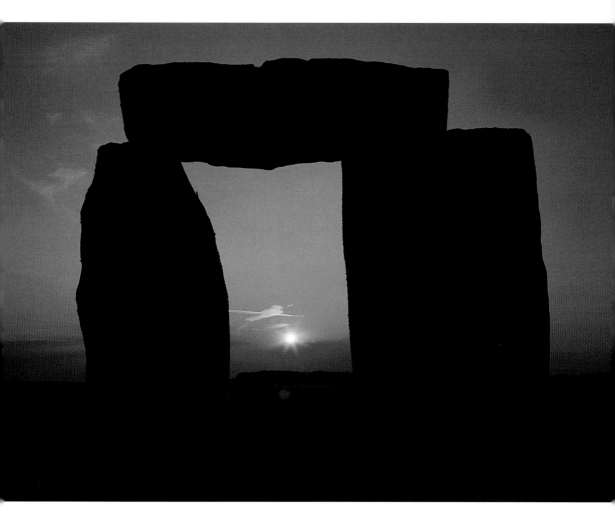

Differing shades of light

Photographing famous subjects at different times of the day allows you to capture different moods – and if you are lucky you don't actually have to be at the location very long. The shot of the sunset has immediate photogenic appeal – but because of Stonehenge's association with the summer solstice, the late evening shot has even more significance. Immediately above, the stones are given a different, almost bleak and sinister, appearance in the blue light just before dawn on a winter's day.

Keeping stocked up

Finding film
One of the most frustrating things you can do is to run out of film when away. Always try to pack more than you are likely to need. Many tourist attractions are away from the shops, and you may not find the film that you want.

Saving money
Even if in a big city, and you find your favourite film, it may be two or three times the price you pay a mail-order specialist at home.

Power game
Just as important as film are batteries. If these run down, modern cameras will not work at all. As they come in many shapes and sizes, the ones you need might not be easily available at your destination. So take a spare or two.

Temperature control
Batteries will run down quicker in cold climates (although they may come back to life once they get warm again). So take even more spare cells.

Assignment 4
New York

Although the photographer is always after that perfect picture, it is important to realise that a single shot never sums up a location. The only way to give a true feeling of your holiday destination is with a varied portfolio of shots. Pictures of the cathedrals, castles and other landmarks on their own only show a blinkered view of the location. A set of holiday shots that also shows the people, the atmosphere and the way of life of a place will be more rewarding than just having picture-postcard views.

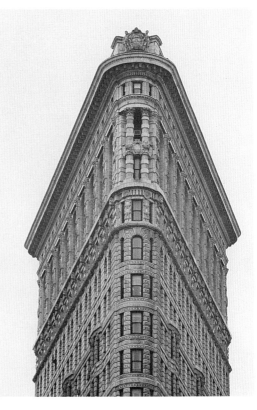

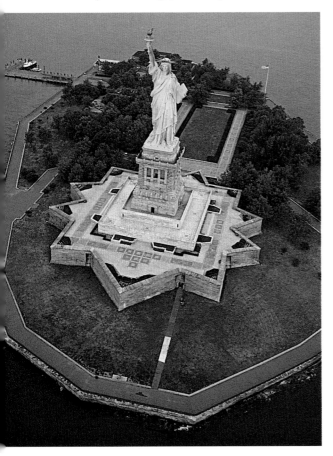

Photographing the landmarks

People have been photographing the extraordinary shape of the Flatiron building for over 100 years. Such pictures may be irresistible, but shots of the buildings alone never give a complete view of a city.

Indirect view

Look out for modern glass buildings. These are not just great subjects for abstract close-ups – they reflect the buildings around them. Often this allows you to juxtapose old and new in an interesting way in the same frame.

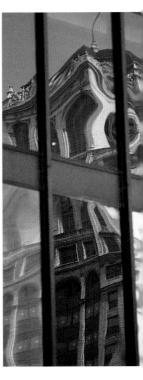

Unique views

Helicopter rides give you a unique view of a city – and they can be much less expensive than you think. They only last a few minutes, though – so you have to make the most of the opportunity, and ensure you don't go on a cloudy or hazy day.

Alternative view

You might normally try to avoid including cars and street signs in your pictures. But in a big city it is the wide roads that give it much of its character. The street signs all have associations – and even the shape and colour of the taxis are often linked with that particular city.

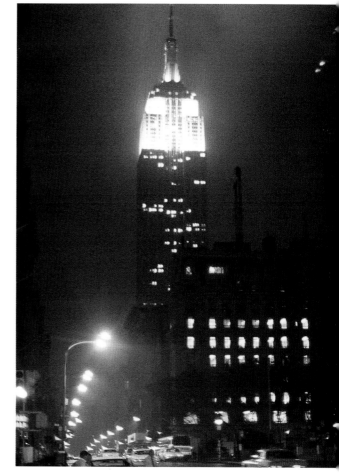

The late shift

Don't miss the opportunity to photograph famous buildings after dark. Many of them are floodlit for at least part of the night, and with a tripod or other solid support, you can capture colourful pictures – even in poor weather conditions.

Framework

A great example of how using natural frames (see pages 60–61) can actually make a picture for you. The bus and the passenger on their own would make dull photographs – but framed within the shape of the vehicle's window, the portrait comes alive.

Providing scale

Murals have become a common feature of many cities, but cropped tightly you have little idea of their context or of their size. By including the playground in the foreground of this shot, you can see exactly how large the artwork really is.

Faces from the crowd

Often it is the people that you meet on holiday that provide the lasting memories of the destination. It therefore makes sense to pluck up your courage and make sure that you capture them on film for posterity.

Foreground interest

Many people photograph their friends and family in front of the places they visit. Often it is worth adopting a similar approach yourself – but using local people going about their daily business to fill those gaps in the foreground. Two mounted police officers make a great focal point for this NY street scene.

Looking out for yourself

Personal security
Wherever you live in the world, there is always the risk of being robbed. But when you are in an unfamiliar place you are always at more risk.

Danger zones
Certain areas in every city have particular reputations for street crime – knowing where these are will help you to be vigilant. Be especially careful after dark.

Be discrete
A photographer flashing around expensive camera gear could attract muggers. Use a nondescript camera bag which doesn't give away its contents. Keep your gear away out of sight whenever possible, especially whilst you are travelling or when in crowds.

Assignment 5
Machu Picchu, Peru

Some places that you visit on holiday you have to make a special effort to get to. Invariably it means a long day and a long trek – and often the only feasible and affordable way of getting there is with an organised tour. On such occasions, the amount of time you have at the location will be limited. It pays therefore to do more research than normal. Get the maps of the area in advance and work out in which direction the sun will be during your visit. You can then begin to prioritise your shots and plan your route so you get the most from your brief stay.

Altitude adjustment
At high altitude it pays to use a UV or skylight filter for panoramic views (right) – otherwise things in the far distance will look too blue. The filter is not necessary, however, when photographing subjects that are reasonably close to the lens (below).

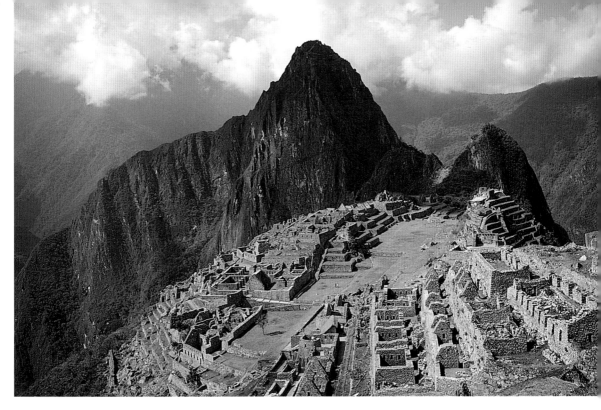

Head in the clouds

In mountainous areas, the weather changes quickly. High in the Andes, Machu Picchu can often be, quite literally, lost in the clouds (below). You have to make the most of the times when the sun breaks through to light up the ancient Inca settlement.

Windows of opportunity

Despite their highly developed architecture and craftsmanship, the Incas did not discover the arch. The large oblong windows and gateways in Machu Picchu (left and below) provide useful compositional devices – allowing you to cut some of the hazy background out of shots of the ruins.

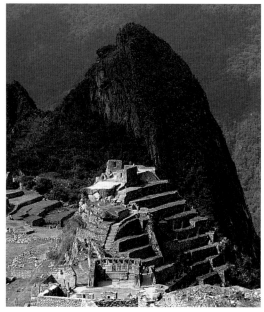

Top of the form

The round-topped mountains and numerous terraces create fascinating three-dimensional shapes – but you need the lighting to be at the right angle to show these up well.

Tortuous route

Keep your camera ready on the trip to the location. The hairpin roads show why people travel to Machu Picchu by train or on foot.

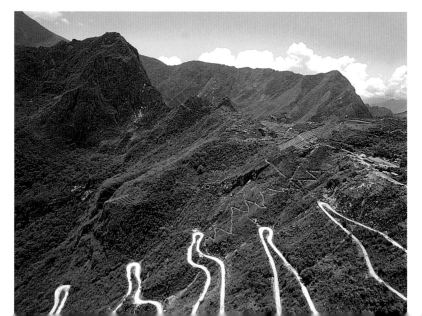

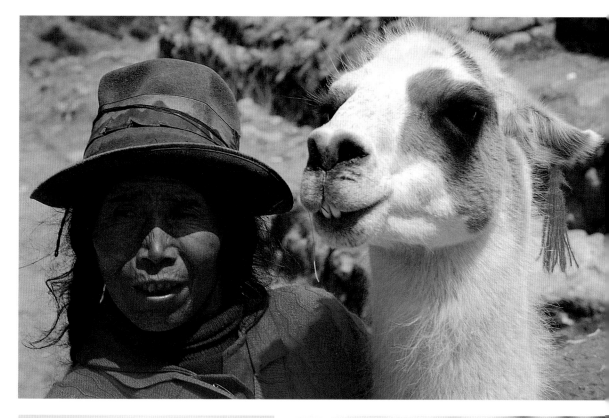

X-ray effects

The problem
X-ray machines used at airport security, and elsewhere, can fog film – but the effect is usually so slight that you do not notice.

Keep your film with you
Some machines give a higher dose of X-rays than others. Those used for baggage destined for the hold are more powerful than those used for cabin bags – so take film as hand luggage.

High-risk passengers
The effect of X-rays is cumulative – so if your trip involves lots of stopovers, you might consider buying some of your film *en route*. Also, some films are much more prone to X-ray damage than others. Higher-speed films are harmed more quickly – as are APS films, as they have a plastic, rather than metal, casing.

Be prepared
To check a camera, security personnel may ask to see the lens taken off SLRs, or for the screens on digital cameras to be switched on

Other hazards
Extreme heat also harms film. Keep processed and unused film in the plastic tub it came in to prevent damage from chemical contaminants (such as furniture glue), as well as dust.

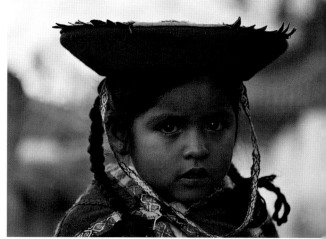

Lighting extremes

Despite its remoteness, I knew that there would be opportunities to photograph typically dressed Peruvians at, and around, the Inca site. The lighting did not make this easy, however. When the sun broke through the clouds it provided harsh lighting on faces – creating strong shadows, particularly under their headwear (as in the shot at the top of the page). When the sun disappeared in the clouds, the lighting became very soft – creating low-contrast, monotonal portraits (as in the shot above).

Assignment 6
Greenwich

With architecture and landscapes, it pays to take that extra second or so over the composition – making sure that buildings are as upright as possible and that horizons are dead level. Even being a degree or so out will look obvious later. Use the edges of the frame to ensure the relevant lines are parallel. If using a tripod, a miniature spirit level can be bought to ensure the camera is not tilted.

Shift lens

To avoid converging verticals with this wide-angle shot, I used a 28mm shift lens. The design of this specialist lens allowed me to raise the lens, without having to tilt the camera itself.

River reflections

Shot from across the River Thames, I wanted to show the symmetry of the Royal Naval College and the Queen's House beyond. To ensure everything was lined up with my standard lens, I used a tripod and triple-checked that everything was as level and upright as possible.

Wide-eyed view

Not far from the heart of London, Greenwich is home to some of the most elegant buildings in England. For this general shot I used a 28mm wide-angle.

Monopod

To zoom in on these stone statues, I used a focal length of around 150mm. To ensure the shots were as well-framed and as crisp as possible, I used a monopod to give the camera extra support.

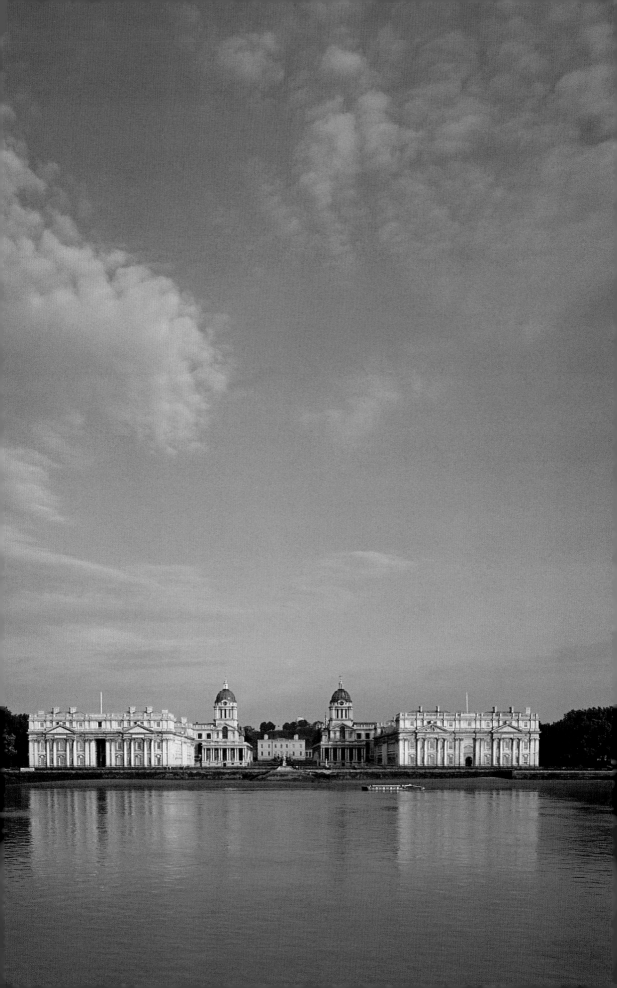

Drop front

Shift lenses are not just useful for the ability to fit in the tops of buildings without tilting the camera. They can also be used in an almost opposite way. This shot of the Chapel at the Greenwich Naval College was shot from a balcony – but I wanted to show the floor as well as the ceiling whilst keeping the back of the camera perfectly upright. By dropping the front of the lens, I could do this without risk of distortion.

Perfectly centred

Many grand buildings suit being positioned in the middle of the viewfinder, so that the symmetry of the architecture is accentuated. But in order to do this you must take care with the framing – get the building slightly off-centre or on the skew, and the effect will be completely lost.

Branch lines

The Royal Observatory, where longitude measurement begins and Greenwich Mean Time originates, stands on a hill. To make full use of the frame, I took advantage of an overhanging tree to fill the foreground.

Indoor detail

Unless you get special permission, tripods are not usually allowed in grand houses. You may well get away with a monopod, however. The shot (opposite) shows a detail from the Chapel.

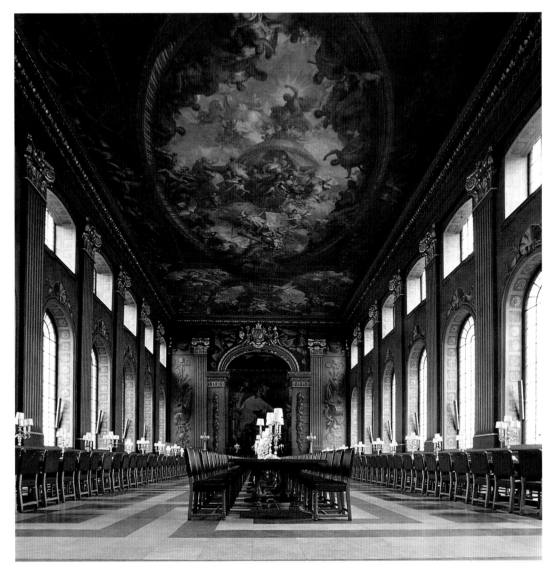

Showing the ceiling

Another shot of Greenwich where a shift lens proved invaluable. Here it allowed me to include the rich murals on the ceiling of the Painted Hall, whilst still keeping the pillars around the room perfectly vertical.

Supporting roles

Tripods

Tripods are the best accessory for keeping the camera rigidly still for long exposures – but they are not the easiest thing to take on holiday, or carry around. Miniature table-top tripods, however, are worth considering for night shots.

Monopods

Tripods will not be allowed in many places, anyway. An alternative in these situations is a monopod; these are easy to pack and carry, and can be used discreetly inside buildings without drawing undue attention to yourself. They do not give rigid support, however. With practice, though, you can expect a monopod to allow you to use shutter speeds that are four times longer than the slowest you would normally use with a handheld camera.

Assignment 7

Norway

It is fun sometimes to follow a theme with your holiday pictures. The idea is that you end up with a portfolio of pictures that are linked not by specific location, but by something that is typical of the whole area you are in. In this way you can add to your collection of pictures on most days of your break. Examples include the covered bridges of New England, the alpine flowers of Switzerland, shop windows of Paris, the colourful hats in Nepal, market stalls in Asia, or pillar boxes in Britain.

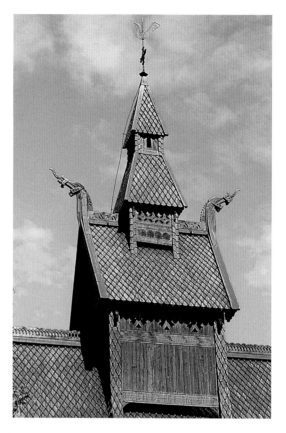

Stave churches

On a visit to Norway, I was fascinated by the pagoda-shaped churches that I came across. Despite being made out of wood, some of these buildings were over 800 years old. There are around 30 of these stave churches in the country – and I therefore made it a project to see as many as possible of them during my stay.

Patterns

Close-up shots of the churches can be used to reveal patterns in the tiles, and in the vertical rows of logs that were used in the construction.

Wooden heart

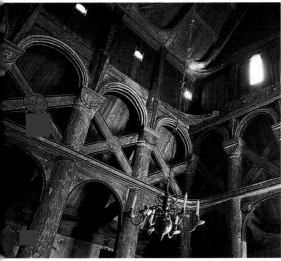

An interior shot of a stave church shows just how much wood is used. With timber being so readily available, the structures were solidly built. This shot was taken using a Vivitar flashgun, used off-camera, to avoid hotspots and to help create some modelling on the wooden pillars.

Abstract art

By zooming into the roof of one of these Norwegian churches, I have isolated the mosaic pattern created by the rounded tiles.

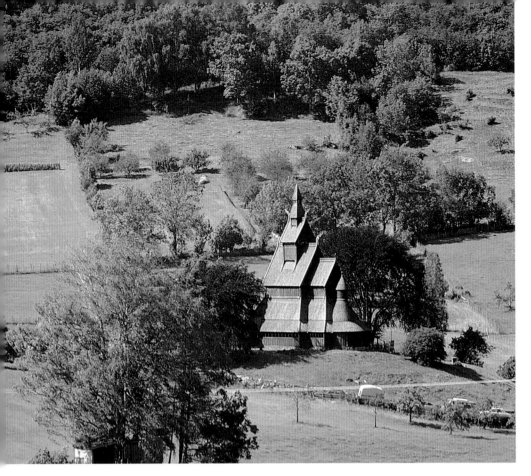

Part of the scenery

In many of the pictures in my portfolio, I framed the stave churches so that they would also show some of the Norwegian landscape that they are surrounded by. Frequently these wooden structures were surrounded by lush countryside, and were set apart from modern civilisation. Where possible I tried to include the better-known features of Norway – the fir trees and the fjords.

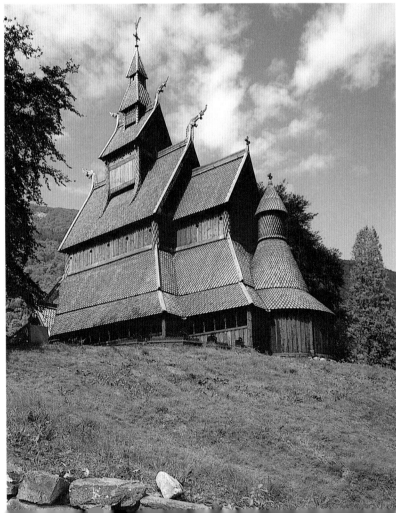

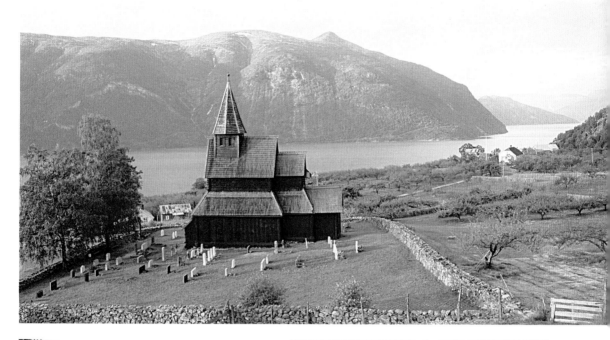

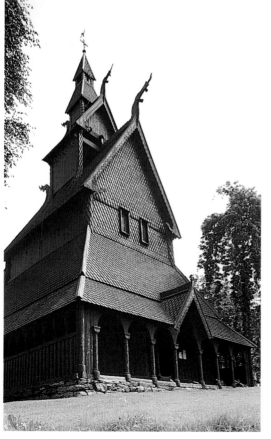

Insurance matters

Where you stand
Although you may have your photographic gear insured when you are home, your household policy may not cover you when you are abroad.

Travel policies
Many holidaymakers buy travel insurance from their travel agents, which provides cover in the case of illness, accident and other disaster. This will also provide some cover if you lose your baggage – or your hotel room is robbed. However, the maximum value for any one item lost may well be as low as $150 (£100) – which is far from adequate when most people's photographic gear costs several times this.

Specialist cover
Unless you are willing to take the risk yourself, the solution is to get cover against loss from a specialist broker. You will be able to get the exact amount of coverage for the gear that you own and the places that you are visiting.

Read the small print
Policies differ – check the amount of excess you will have to pay for any claim. Many may not include coverage from a vehicle even if gear is locked in the trunk (or boot), and you may well need a special policy if you make any money from your photography.

Assignment 8
Taj Mahal

Making the most of a photogenic location is not simply a matter of exploring the subject from every angle in the vicinity. Many monuments, buildings and even cities look at their best when seen from a distance. A key advantage is that you have an almost unlimited choice of foreground – but it means investing more time and effort. You will need to persuade tour drivers to stop en route to the site, or find your own vantage points on foot or by car.

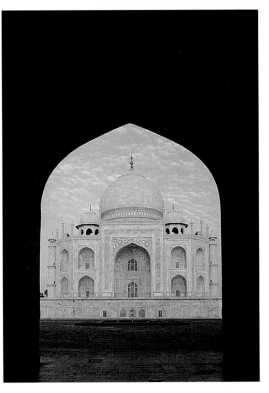

Archetypal shot

The Taj Mahal in Agra, India, is one of the most photographed buildings in the world. Some ways of photographing it have become more popular over the years than others. Shots taken through the conveniently placed archways around the complex are well-proven ways in which to frame this beautiful monument.

Ever-changing moods

One of the characteristics of the Taj Mahal is that the white marble of the memorial changes with the light and the sky. These changes record well on film – helping the camera user to get a variety of different images.

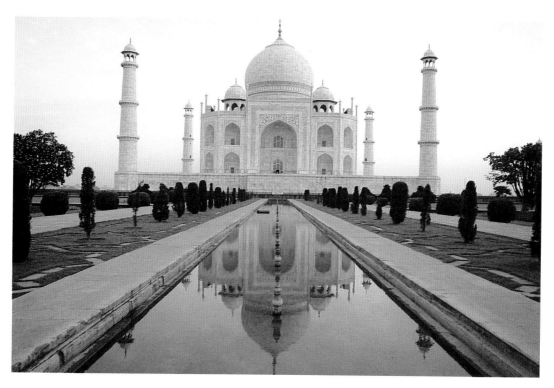

Perfect reflection

Many others have taken the shot from the same angle, but this is still the most satisfying view of the Taj Mahal (above). With the dome reflecting in the waterway running along the paths to the monument, the shot's symmetry suits the subject perfectly.

Multi-faceted subject

Looking virtually the same from all four sides, it is possible to find more unusual views of the Taj Mahal even within the monument complex. This side-on view (below) provides a foreground that is very different from the shot above.

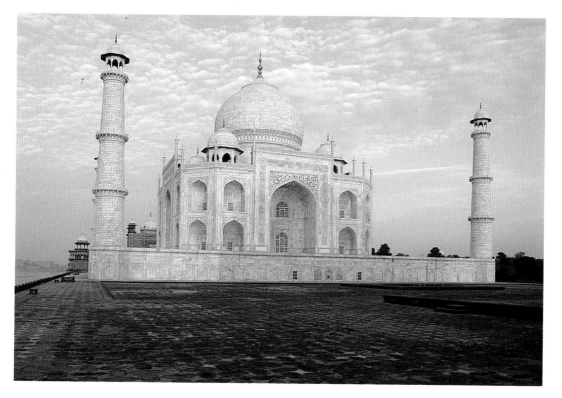

Distant views

Shots from across the river provide a different viewpoint, and an opportunity to use longer lenses. But the real attraction of being further away is that you can frame the subject with such a wide variety of foregrounds. A crumbling wall, a passer-by on the bank of the river and a boatman all provided me with different, if not unique, interpretations of the much-photographed monument.

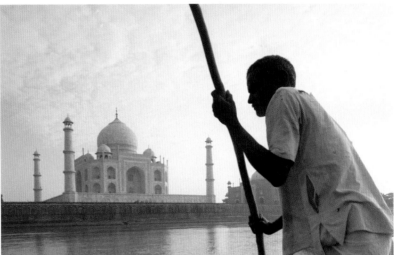

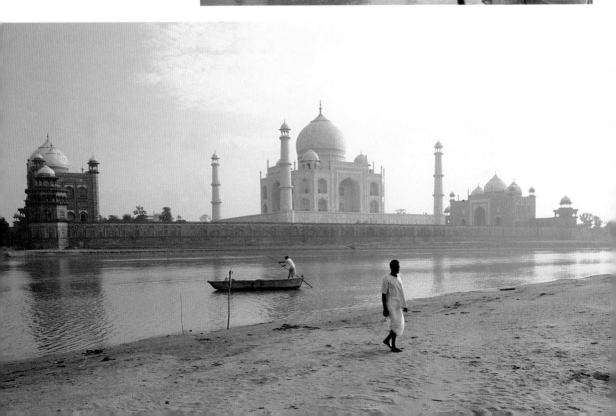

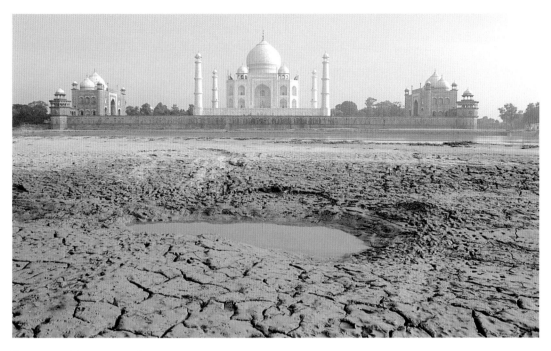

Patterned foreground

Another shot from across the river, showing the advantage of the distant approach. Here the cracked mud of the dry river bed creates a strong foreground.

Miniature model

Whilst in Agra, I was asked to do a shot for the hotel I was staying at. I said I would, if they provided me a replica of the Taj in icing sugar. They did this overnight, so I kept my promise with a complex shot that combined fine food, staff and elephants (below).

Restricted and sensitive subjects

Keeping on the right side of the law
Every year photographers end up in prison in a foreign country for pointing their cameras at the wrong subject. The laws as to what can't be shot vary widely from country to country.

Military targets
The most obvious places to avoid taking pictures are at airfields, army bases and naval dockyards. If you shoot in these places you could be accused of espionage. Even where it is not strictly illegal you could be asked a lot of awkward questions. In many places, airforces share runways and facilities with civil airports.

Strategic structures
In some countries they will not take kindly to photographing certain key civil structures – for fear of espionage or terrorism. Such subjects might include dams, bridges, railways, power stations, and oil refineries. Embassies should be able to tell you of specific bans, or for the need of permits for particular subjects.

Show some respect
Different religions, customs and moral values mean that taking photographs of certain subjects may cause offence in other parts of the world. Sites and ceremonies with religious significance are obvious examples. Photographing women and native tribes may cause a problem in some places. If in doubt ask a guide, embassy, or the subject of your photograph. Tact and diplomacy will usually avoid any problems.

Assignment 9
Petra, Jordan

One of the most annoying problems with taking pictures at popular tourist attractions is other photographers. As soon as they see you take a picture, they invariably decide to take exactly the same view – and they can end up getting in your way, standing in your shot and breaking your concentration. At a busy site, you can soon draw a large crowd! I try and keep my camera concealed at my side, waiting for the right light or the clouds to clear before lifting up to my eye – I then take the picture as quickly as possible so as not to draw too much attention to myself.

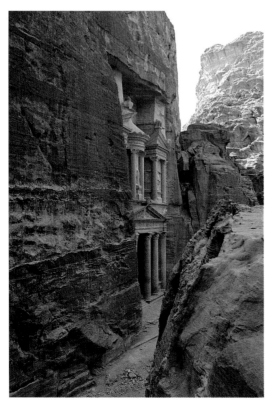

Window of opportunity

The only entrance to the ancient city of Petra is through a narrow gorge – which in places is only 12 feet (4m) wide. Thousands of tourists trek through this passage, known as The Siq, every day. It pays to be quick, and patient, if you want unspoilt shots of this path (above) or of the narrow streets of the city itself (left).

Original views

It is when you find an interesting shot of something that is not obviously photogenic that others will tend to copy what you are doing. This is one of the lesser-known tombs in Petra, but it still pays to be secretive if you want to be left alone.

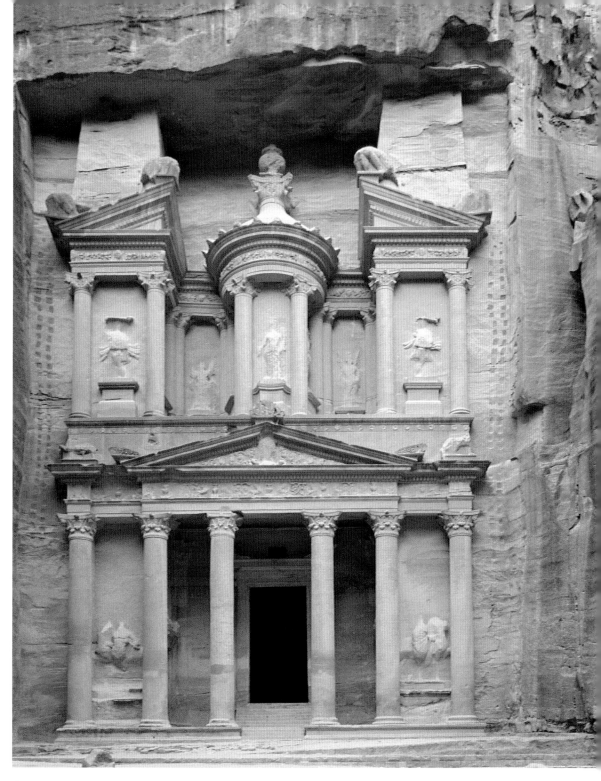

Crowd trouble

The Treasury, or Kazneh, is the first building that you see as you walk into Petra – and it is also the most photographed of all of the structures in the 2000-year-old desert city. It was not built – it was literally carved out of the rock. The problem with this shot is not that you might attract other tourists – everyone has their cameras in their hand at this point. But you need to be there early, and wait quietly to get a picture of the place looking deserted.

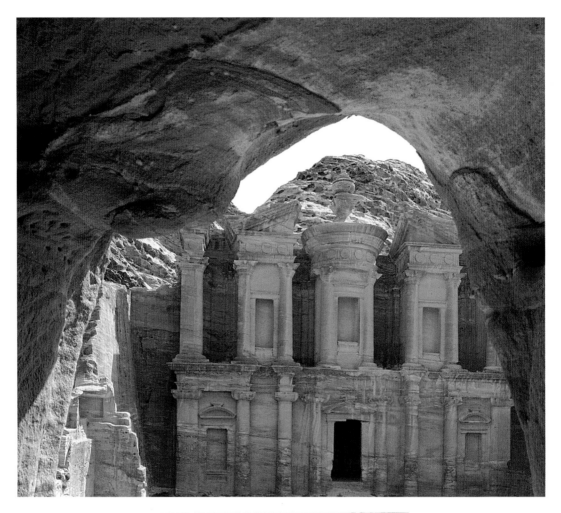

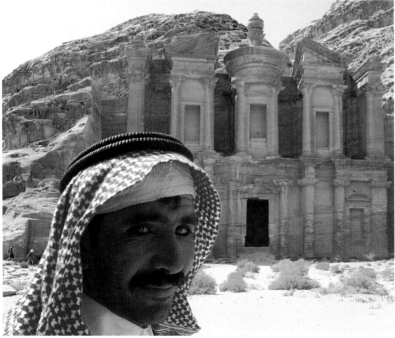

A question of scale

The huge rock-hewn structures of Petra create an interesting photographic problem. The Monastery, shown in all three pictures here, is some 150 feet tall (45m). The straight frame-within-a-frame shot (above) gives no idea as to this size. Adding the figure to the shot (left) does little more to suggest scale, as to get the person large enough in the frame, he has to be quite a distance from the building. Only when we see the third shot, a close-up of the detail on top of the building (right), do we see the enormity of the total structure; this urn dwarfs the man sitting beneath it.

Candid camera

I liked the way in which these three horses stood statuesque against the desert landscape (above), waiting patiently for their next duty.

Avoidance tactics

The rockfaces in and around Petra are littered with caves and tombs – many of which you can enter. But I found that if I went in, others would follow out of curiosity. If I then got out my camera, they would stay. I therefore adopted the approach of reading my guidebook once I had entered the cave – and my followers would then soon leave. This left me free, unseen, to take pictures of the beautiful wave-like patterns of the stone (right). As the caves were not deep, these close-ups were lit simply by daylight permeating through the entrance.

General view

Fellow photographers create few problems with panoramic views, as a slight change in camera position makes little difference, so there is usually enough room for everyone – as with this shot of the hillside tombs around Petra.

Close quarters

Vegetation in the desert regions is always worth capturing as it shows the power and beauty of nature.

Keeping it clean

Why
Dust and dirt on the front of your lens will affect the quality of the pictures that you take, and if not dealt with properly will damage the glass.

First line of defence
Take a blower brush for removing the worst of the dust from the lens. Brush gently, whilst squeezing and releasing the bulb.

Stubborn marks
Pack a microfibre cleaning cloth for removing fingerprints and other marks from the front element, viewfinder, LCD screen, and filters. Available from specialist photographic stores or opticians, this will clean the surfaces without damage. Resist the temptation to use your shirt, towel or handkerchief.

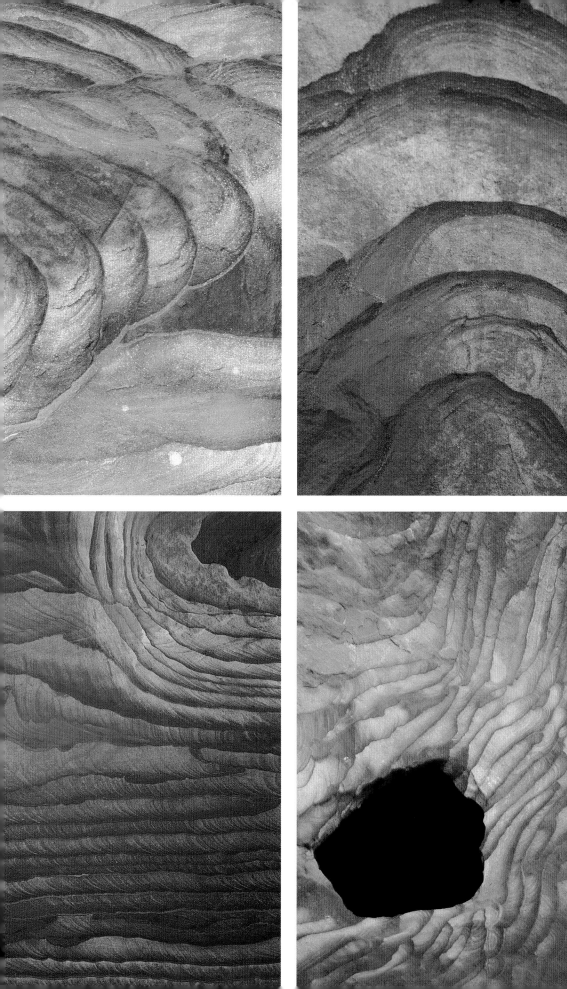

Assignment 10
Mykonos

If you don't ask, so the saying goes, you don't get. This is excellent advice for the travelling photographer – because the best pictures often come from having the initiative to ask if something is possible. The most obvious example is with pictures of people. Sometimes you can shoot candid shots of locals – but you will have more choice of camera angles if you get the subject's cooperation. They may say no – but will often be flattered by the request. Asking may also get you special access – you may get into a busy site a few minutes ahead of the crowds, or may gain you a unique bird's-eye view from a private roof.

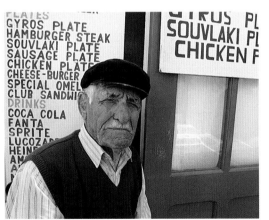

Making friends with the locals

Wherever I travel in the world, I am fascinated by people's faces. Rather than shooting surreptitiously, I ask (or gesture) if they mind whether I take a picture. This allows me to get close to the subject – and to end up with a variety of different shots. Often, this then leads to a conversation – which may provide you with interesting local knowledge to help you find further photographs.

Last-minute packing

Keep connected
Digital camera users must remember their
battery charger, and a universal plug adaptor

Emergency repairs
Duct tape, a jeweller's screwdriver and a small
pair of pliers can be invaluable for all sorts of
minor repairs – photographic or otherwise.

Night light
A miniature torch will allow you to see what
you are doing when taking pictures after dark.

Shoulder pads
Comfortable straps for both bag and camera.

Making notes
Put paper and pencil in your camera bag, so
you don't forget the names of the places you
have taken pictures of.

Reading material
Take the instruction manual for your camera, to
refamiliarise yourself with every control.

Index

Acknowledgements

The author would like to thank the following for their help in producing this book:

The Government Tourist Offices of the following countries: Austria, Guernsey, Iceland, India, Isle of Man, Jersey, Jordan, Mexico, Romania and Spain.

Miltos Denoulis, The Andromeda Hotel, Mykonos, Greece.

Minolta Cameras
Olympus Cameras
Pentax Cameras

Agfa Films (the majority of the pictures in this book were taken on Agfa RSX 50, 100 and 200 ISO film)